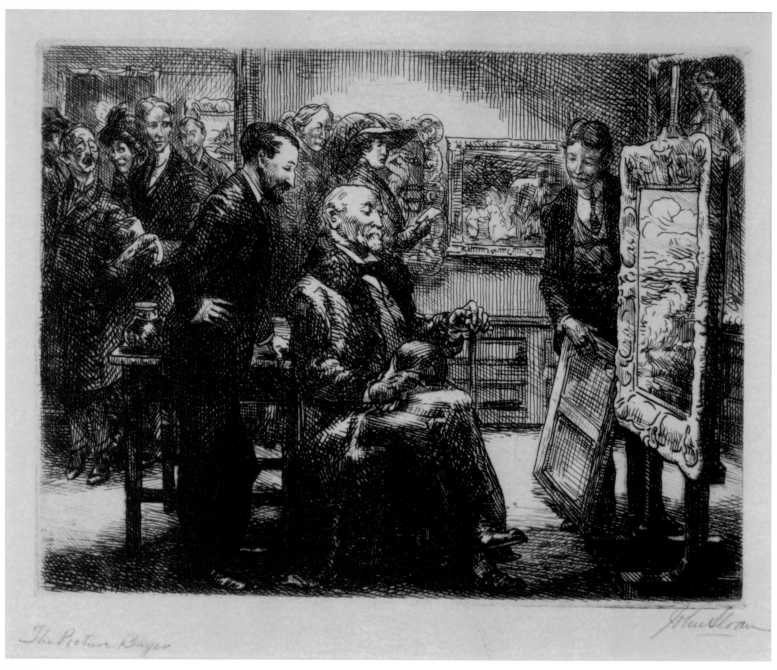

John Sloan (1871–1951). *The Picture Buyer,* 1911. Etching, 5¼ x 7 in.

American Reflections

The Collection of Dr. Timothy McLaughlin

New Britain Museum of American Art

Distributed by University Press of New England
Hanover and London

This book is published in conjunction with the exhibition *American Reflections: The Collection of Dr. Timothy McLaughlin,* organized by the New Britain Museum of American Art.

New Britain Museum of American Art
New Britain, Connecticut
September 10–October 24, 2010

New Britain Museum of American Art
56 Lexington Street, New Britain,
Connecticut 06052-1414
(p) 860-229-0257 (f) 860-229-3445
www.nbmaa.org

Distributed by University Press of
New England
One Court Street, Lebanon,
New Hampshire 03766
www.upne.com

Edited by Pamela Barr, New York
Designed by Melissa Nardiello
Photography by John Urgo and
Alex Morganti

Library of Congress Control Number:
2010928740
ISBN-10: 0-9724497-0-1
ISBN-13: 978-0-9724497-0-0

Printed in the United States of America

Cover: Aaron Draper Shattuck (1832–1928).
Landscape, Sunset over the Hills. Oil on canvas
laid onto board, 12½ x 18¼ in.
Back cover: Childe Hassam (1859–1935).
Fireplace in the Old House, 1912. Oil on cigar
box panel, 5½ x 9 in.

Contents

Director's Acknowledgments 6
 Douglas K. S. Hyland, Ph.D.

Curator's Introduction 7
 Alexander J. Noelle

Collector's Acknowledgments and Statement 8
 Dr. Timothy McLaughlin

Contributors 10

Connecticut Composed 12
 Erica E. Hirshler

James Carroll Beckwith, *Portrait of a Lady*
 (*Study of Minnie Clark*) 16
William Chadwick, *Millstone Point* 18
Bruce Crane, *May Moon* 20
Asher B. Durand, *Landscape with Cattle* 22
Ben Foster, *The Meeting House* 24
Sanford Robinson Gifford,
 Hudson River Highlands 26
James McDougal Hart, *Farmington River* 28
Childe Hassam, *Fireplace in the Old House* 30
Robert Henri, *Untitled*
 (*Nude with Arm over Head*) 32
Wilson Henry Irvine, *Sunlight and Shadows* 34
Wolf Kahn, *Richard Hamilton Barns* 36
John Frederick Kensett, *A View in Italy* 38
Sol LeWitt, *Tangled Bands* (*Blue*) and
 Tangled Bands (*Red*) 40
Lawrence Mazzanovich, *Autumn Afternoon* 42
Graydon Parrish, *Rose* 44

William McGregor Paxton, *Reclining Nude* 46
Rembrandt Peale, *George Washington* 48
Henry Rankin Poore, *The Horse Pasture* 50
Henry Ward Ranger, *Interior of a Wood* 52
Henry Ward Ranger, *A Ledge of Rock* 54
Aaron Draper Shattuck, *Landscape,*
 Sunset over the Hills 56
John Sloan, *Connoisseurs of Prints* 58
John Sloan, *The Picture Buyer* 60
Edward Gregory Smith, *By the Edge of the*
 Lieutenant River, Old Lyme, CT 62
Peter Waite, *Hill-Stead* 64
John Ferguson Weir, *East Rock, New Haven* 66
James Abbott McNeill Whistler, *Billingsgate* 68
James Abbott McNeill Whistler, *La Robe Rouge* 70
Thomas Worthington Whittredge,
 Catskill Mountains Twilight 72
Guy C. Wiggins, *Times Square* 74
Illustrated Checklist 76

Director's Acknowledgments
Douglas K. S. Hyland, Ph.D.

The late art historian Douglas Cooper differentiated between two major types of collections: "historical," built up over the centuries, and "personal," the direct result of the creative activity of one individual.[1] The collection of Dr. Timothy McLaughlin conforms in every way to the "personal" variety. From the moment I first glimpsed the McLaughlin collection more than ten years ago, I knew it directly mirrored Dr. McLaughlin's particular love of tranquility and his pursuit of the ideal as expressed by many of our most distinguished Hudson River School painters. His sensitivity to the nuances of Luminism, Romanticism, and other currents of nineteenth-century American art led him to Asher B. Durand, Sanford Gifford, and Aaron Draper Shattuck. Living for more than three decades in Connecticut, he has been captivated by views of the unspoiled fields, hills, and streams of the state's Impressionist artists. Similarly, his interest in history led him very early in his career as a collector to purchase the portrait of George Washington by Rembrandt Peale. It is a testament to Dr. McLaughlin's broad understanding of art that he has also acquired late twentieth- and early twenty-first-century examples by the Connecticut natives Sol LeWitt and Peter Waite, among others. Thus, this collection reveals the mind and preferences of a man who appreciates American art on multiple levels, the common denominator being the strength of vision and the skill of each of the artists whose work he has acquired over the last twenty years. It is a pleasure to present this exhibition, and I am most grateful to Dr. McLaughlin for his gracious loan, which will afford our visitors a peek into a very "personal" collection.

In keeping with Dr. McLaughlin's interest in scholarship, the Museum invited the nation's leading authorities to contribute insightful, short essays on works in the collection: Jeffrey W. Anderson (Florence Griswold Museum), Kevin J. Avery (Metropolitan Museum of Art), Charles B. Ferguson (New Britain Museum of Art), Linda S. Ferber (New-York Historical Society), Elizabeth Kennedy (Terra Foundation for American Art), Elizabeth Mankin Kornhauser (Wadsworth Atheneum Museum of Art), Susan G. Larkin (independent art historian), Patrick McCaughey (Wadsworth Atheneum Museum of Art and Yale Center for British Art), Marla Prather (Metropolitan Museum of Art), Marian Wardle (Brigham Young University Museum of Art), and Bruce Weber (National Academy Museum). I am grateful for their cooperation and for their time and effort. Furthermore, Erica E. Hirshler (Museum of Fine Arts, Boston) contributed the outstanding introductory essay on the collection as a whole. Additional entries were provided by Alexander J. Noelle, the curator of the exhibition, and the curatorial interns Blair Apgar, Christy Johnson, Carole Jung, Jillian Richard, and Aden Weisel.

While the entire staff has contributed in one way or another to the success of this enterprise, I wish specifically to thank Alexander Noelle for his curatorial work, Melissa Nardiello for the design and publication of the catalogue, Pamela Barr for her editing of the text, John Urgo for the installation, and Claudia Thesing for marketing and public relations. Also, Jeffrey Cooley of The Cooley Gallery made a generous contribution for which we are all very thankful.

1. Douglas Cooper, ed., *Great Private Collections* (New York: Macmillan, 1963), p. 11.

Curator's Introduction
Alexander J. Noelle

The collection of Dr. Timothy McLaughlin is a rich and varied treasure trove spanning the last two centuries of artistic development in the Connecticut region. Even though more than 150 years separate the earliest from most recent acquisitions, there is an inherent connection among the paintings, sculpture, and works on paper presented in this catalogue and exhibition. As Erica Hirshler points out in her introductory essay, the McLaughlin collection is laden with art that encourages—and, in many cases, requires—contemplation and meditation. Lacking intermediary figures that stand in for the viewer, one must approach and study each piece on an individual and even personal level. This subtle quality makes the collection a powerful tool for reflection as well as education.

It is clear that Dr. McLaughlin has found his own connection to each and every work he has acquired. Not only does he glean solace and tranquility through contemplation of the art that adorns the walls of his home, but he also has learned to appreciate the beauty of Connecticut through the eyes of some of its most celebrated, inventive, and nuanced artists. This view of our world is a mix of historical knowledge, artistic vision, and scholarly investigation. Inspired by the gems of enlightenment and perspective buried within the layers of pigment, Dr. McLaughlin invited the nation's authorities to discover their own relationship with the works that comprise his collection. As you will see, the resulting dialogues led to a profusion of information and interpretation. The contributors bring to light details that give the viewer insight into the artists' psyches as well as information that helps us formulate our own connections to their creations.

Dr. McLaughlin's collection and collecting philosophy empower the visitor. Instead of putting together a collection that proclaims an overwhelming stance or thesis, Dr. McLaughlin has carefully selected pictures that call for interpretation. Each one reflects upon a tale, a mystery, or even just a particularly beautiful day in the Connecticut River Valley. In a sense, they are incomplete without someone to admire their details—a sunset in the wilderness, horses gracefully roaming a field, a soft and moonlit night. They ask us to find a personal connection to the area we call home and provide us with the visual tools needed to do so.

By forging such personal connections between regional art and the viewer, the McLaughlin collection will become a repository of favored reflections. It is my hope that these reflections will inspire visitors to utilize this catalogue as an educational resource and to discover more about the artists whose works speak to them. Furthermore, I trust that they will, as has Dr. McLaughlin, use the perspectives of these artists as a means to see the natural beauty of Connecticut in their own way.

Collector's Acknowledgments and Statement
Dr. Timothy McLaughlin

I would like to thank those who have made this exhibition and catalogue possible: Douglas K. S. Hyland, for developing the concept of showing a small and regionally focused collection to the public; Erica E. Hirshler, for her cogent and sensitively written introduction to the catalogue; Alexander J. Noelle, for curating the project so capably; John Urgo, for his photography and logistical management; Melissa Nardiello, for her elegant catalogue design; and Pamela Barr, for editing the text so skillfully. I am tremendously grateful for the distinguished panel of scholars who contributed essays to this project.

I would also like to acknowledge that my involvement with the New Britain Museum of American Art as a current member, a former Trustee, and former Chairman of the Board continues to reward me in many ways so very much more than I have contributed to the Museum.

Initially, I was somewhat hesitant when director Douglas Hyland asked me in mid-2009 if I would be willing to loan my collection to the New Britain Museum of American Art for an exhibition. My paintings were acquired solely to adorn the walls of my home, for my personal pleasure, and for the quiet enjoyment of my family and our friends. I never thought they would be of enough interest to as discerning a museum audience as that of the New Britain Museum of American Art to merit a public display. I find it difficult, however, to argue against any aesthetic judgment that Douglas Hyland feels strongly about, and so "American Reflections" was born.

The paintings were purchased, for the most part, individually from a variety of sources over two decades and were not conceived as a collection. With their presentation in a museum setting for the first time, other art lovers will have the opportunity to explore them for the threads of meaning that tie a collection together and make it more than the sum of its parts. Having distinguished scholars, authors, and art professionals comment insightfully on the works I own is a treat a collector dreams about, and I thank the New Britain Museum for making it possible. The essays in this catalogue lend distinction to this collection of artistic meditations, or "reflections," and, I hope, provide a context within which to understand the works and enhance the viewers' enjoyment of them. The insights provided by the distinguished experts who contributed to the text will give future art lovers a reason to revisit the collection. I am truly grateful to the contributors for lending their expertise.

I suppose I have always collected, since my earliest years. I grew up in a very rural part of Maryland, which allowed me as a boy to collect and study rocks and minerals, arrowheads, birds' nests, turtles, and amphibians from the fields and woods surrounding my house. These collections piqued my interest in the sciences, which led ultimately to a medical education. While at college in Washington, D.C., and at medical school in Baltimore, I found visits to museums a welcome and refreshing break from my studies. I became acquainted with the National Gallery, the Phillips Collection, the Corcoran, the Baltimore Museum of Art, the Walters Art Gallery, and other important museums within minutes of my school. By the time I began to practice orthopedic surgery in Connecticut in the 1980s, I knew I wanted to live with the art I had come to admire. But where to begin?

"American Paradise," the exhibition of Hudson River School paintings mounted by the Metropolitan Museum of Art in late 1987, had a huge impact on me and helped me focus on what made nineteenth-century American landscape painting truly great. I began to reflect on the perfectly ordered visions created by mid-century artists based in New York and came to understand the serenity and peace they could impart. In late 1988 I came across a little gem of a Hudson River School painting created by Asher B. Durand in 1861, *Landscape with Cattle*, at the Armory Antiques Show. I had read Durand's philosophical musings on the spirituality evident in the American landscape and understood what he was attempting theoretically. The painting spoke to me. I decided to afford it. I had recently moved into an old house with lots of wall space, and my career as a collector of American paintings was launched.

I began to gather books about American art and catalogues of painting sales and started visiting dealers close to home and while traveling. I learned of the rich artistic heritage of my adopted state of Connecticut and became very interested in the Impressionist art colonies that developed at Cos Cob and Old Lyme. The dealer Jeffrey Cooley, in particular, was a valuable source of education about the artists who produced awe-inspiring works of beauty within one hundred miles of my home. My collecting focus narrowed to Connecticut artists and regional subject matter.

I began to see everything with the new eyes given to me by the talented artists who lived nearby in the last 150 years or so. On my way to work I would see "Ranger" oaks, "Hassam" skies, "Davis" clouds, and "Church" sunsets. I could appreciate the majesty of distant vistas all the more for having lived with Hudson River School greats, could appreciate atmospheric fog-shrouded fields for having works by the American Tonalists in my home, and, of course, the early sunshine invigorated my morning commute all the more because the Connecticut Impressionists helped me anticipate its glint on a familiar landscape. In short, the works I owned helped me appreciate the beauty surrounding me, which I had been too easily taking for granted. This quality of helping us see what is in front of our eyes is part of the transformative effect of all good art and what continues to draw us to it.

I sincerely hope that this exhibition of paintings by tremendously talented American artists—some famous and others unheralded—will provide viewers with a memorable experience. Please compare your reactions with the erudite commentaries that follow in this thoughtful catalogue.

Contributors

Outside Scholars

Jeffrey W. Andersen
Director
Florence Griswold Museum
Old Lyme, Connecticut

Kevin J. Avery
Associate Curator
American Paintings and Sculpture
The Metropolitan Museum of Art
New York, New York

Linda S. Ferber, Ph.D.
Senior Art Historian
New-York Historical Society

Charles B. Ferguson
Director Emeritus
New Britain Museum of
American Art

Erica E. Hirshler, Ph.D.
Croll Senior Curator of
American Paintings
Museum of Fine Arts, Boston

Elizabeth Kennedy, Ph.D.
Curator of Collection
Terra Foundation for American Art
Chicago, Illinois

Elizabeth Mankin Kornhauser, Ph.D.
Chief Curator and Krieble Curator
of American Paintings and Sculpture
Wadsworth Atheneum Museum of Art
Hartford, Connecticut

Susan G. Larkin
Independent Art Historian
Greenwich, Connecticut

Patrick McCaughey
Former Director
Wadsworth Atheneum Museum of
Art and Yale Center for British Art

Timothy McLaughlin, M.D.
Collector
Orthopedic Surgeon
Farmington, Connecticut

Marla Prather
Senior Consultant
Nineteenth-Century, Modern, and
Contemporary Art
The Metropolitan Museum of Art
New York, New York

Marian Wardle
Curator of American Art
Brigham Young University Museum of Art
Provo, Utah

Bruce Weber
Senior Curator
19th and Early 20th Century Art
National Academy Museum
New York, New York

New Britain Museum of American Art Staff

Blair Apgar
Curatorial Intern

Douglas K. S. Hyland, Ph.D.

Christy Johnson
Curatorial Intern

Carole Jung
Curatorial Intern

Alexander J. Noelle
Assistant Curator

Jillian Richard
Curatorial Intern

Aden Weisel
Curatorial Intern

Connecticut Composed

Erica E. Hirshler
Croll Senior Curator of American Paintings
Museum of Fine Arts, Boston

Although he grew up in Maryland, Dr. Timothy McLaughlin feels like a native of Connecticut; he has adopted the state, or has allowed himself to be adopted by it, and he holds a deep affection for its rocks and wooded hills, for its history and heritage.[1] "The man who loves New England and particularly the spare region of Connecticut loves it precisely because of the spare colors, the thin lights, the delicacy and slightness of the beauty of the place," declared the poet Wallace Stevens in a national radio broadcast in 1955. Stevens was the author of complex philosophical poems that address observation, perception, and reality; at the same time, he worked—hard and successfully—for a large Hartford insurance company. Originally from Pennsylvania, he frequently found his artistic inspiration in the Connecticut landscape, which he embraced as his own. "Once you are here," Stevens wrote, "you are or you are on your way to become a Yankee. I was not myself born in the state. It is not that I am a native but that I feel like one."[2]

Like Stevens, Dr. McLaughlin has espoused Connecticut while also dividing his world between issues of logic and those of aesthetics. A practicing surgeon, he has created an artistic refuge in an old Connecticut house filled with canvases by painters associated with the state. The house forms a sanctuary; the paintings speak to their owner of peace and serenity, acting as an antidote to the hurly-burly of his professional orbit. "It is a question of coming home to the American self," to use Stevens's words, "in the sort of place in which it was formed. . . . It is an origin which many men all over the world, both those who have been part of us and those who have not, share in common: an origin of hardihood, good faith and good will."[3] With much good faith and good will, Dr. McLaughlin has decided to share his collection with the public, hoping that visitors to the New Britain Museum of American Art will find, as he has done, inspiration, solace, and pride in the accomplishments of Connecticut's painters.

Connecticut "has given the world more artists of acknowledged ability than any other State," Henry W. French declared in

his 1879 monograph on the topic, and he went on to describe the works of more than 160 painters and sculptors with connections to the area.[4] His criteria were liberal; French included men and women who were born in Connecticut, others who settled there permanently or temporarily, and even those who had simply passed through. McLaughlin has been equally open-minded about defining his sphere, collecting some works that appealed to him for their geographic accuracy, others that communicate the spirit of the place, and some that break with its character deliberately—a New York cityscape, a stylish woman in an interior, a colorful abstraction. The collection is changing over time, nurtured as a living and growing entity.

The first painting Dr. McLaughlin purchased was a pastoral river view in a classical style by Asher B. Durand. It has nothing to do with Connecticut but everything to do with what can be found in its landscape: order, clarity, and, most of all, a supreme sense of calm and tranquility. Durand worked in a formula established by the much-admired seventeenth-century French landscape painter Claude Lorrain, creating a carefully balanced vista through which the eye meanders, traveling vast distances within a composition not much larger than a sheet torn from a legal pad. Cows graze placidly in the foreground, man's presence is only lightly impressed on the land (the road, the scattered houses, a distant sail), and the scene is suffused with a golden light that Durand found sacred. "The true province of Landscape Art," Durand wrote, "is the representation of the work of God in the visible creation, independent of man, or not dependent on human action."[5] Through this painting, and others like it that soon entered his collection, Dr. McLaughlin discovered the redemptive power of landscape—the heavy, suffused light of Sanford Gifford's view of the Hudson, the river waters so calm that they serve to mirror the high cliffs that line its banks; the delicate tints of blue and violet in Worthington Whittredge's gemlike panorama of the Catskills; the clear golden light of John F. Kensett's Italian scene, the earth marked by generations of men; and the last dramatic red

glow of the sun as the land beneath it succumbs to darkness, captured forever in Aaron Draper Shattuck's anonymous and seemingly unpopulated wilderness.

With Kensett, who was born in Cheshire and spent many of the last years of his career near Darien, and Shattuck, who moved to a farm in Granby in 1870, the collection takes a decided turn toward Connecticut. Dr. McLaughlin relates that the artists of the Hudson River School taught him to look at landscape painting and to discover the meanings that could be communicated through it, mysteries that could be contemplated in the ordinary and familiar. He then began to seek images of places that had personal resonance. James McDougal Hart's Farmington River pastoral, John F. Weir's somewhat forbidding view of East Rock, Henry Ward Ranger's oak forests and abandoned stone walls, Lawrence Mazzanovich's scrim of autumn foliage, William Chadwick's enveloping forest of laurel: all of these are familiar sights to a lover of Connecticut's landscape. In each case, however, the viewer is asked to look beyond the readily identifiable subject matter and to enter a quiet and private world of contemplation, as if, as Dr. McLaughlin has done, we ourselves are experiencing the meditative peace and beauty that can come from a solitary journey outdoors by foot or kayak. There are no intermediary figures in the paintings themselves; we confront each scene directly and thus experience the contemplative, healing power of place.

This sense of reflection, perhaps somewhat rooted in nostalgia, permeates the collection and links these landscapes with the figurative works by James Carroll Beckwith and Childe Hassam. Beckwith's *Portrait of a Lady* captures the likeness of one of his favorite sitters, a professional model admired by several artists for her ability to personify the vitality and purity of a celebrated national type popularized by Charles Dana Gibson.[6] Here, Minnie Clark does not command a public stage but sits in a vaguely defined interior, lost in a moment of introspection. Similarly, in Hassam's small panel, a woman reads before a fire, a timeless illustration of

tranquility. While the compositional format and intimate size of this work recall James Abbott McNeill Whistler's tightly cropped images of storefronts, with their interlocking repetitions of squares and rectangles, Hassam's setting is clearly New England and specifically Connecticut—the dining room of the Bush-Holley House in Cos Cob. Hassam made several paintings of this well-known interior, carefully constructing confections that celebrate America's heritage and traditional values while also serving as reminders of the inspirational power of art.

When French wrote his survey of Connecticut's contribution to the arts, some of the men and women who became the state's leading painters were still babes in arms and the aesthetic movements they espoused were yet to take hold. The artists' colonies at Cos Cob and Old Lyme, for example, best known as incubators of the Impressionist style in the United States, began to coalesce only during the 1890s, continuing to flourish well into the twentieth century. No compilation of Connecticut art today would be complete without them. In the McLaughlin collection, Hassam represents the Cos Cob group, whose works have earned national acclaim. The Old Lyme artists include Bruce Crane, whose tonal moonlit farmstead converts the familiar into a poetic mystery, and Edward Gregory Smith, who transformed an anonymous view of the Lieutenant River into an exploration of bands of color and vibrating pattern. Dr. McLaughlin has taken his collection even further in time, selecting not only the contemporary realists Tom Yost and Peggy Root, whose luminous paintings speak to their ancestors in his assembly, the Whittredges and the Shattucks, but also embracing Sol LeWitt, whose abstract and minimalist progressions of lively line and color are equally integral to the story of art in Connecticut. LeWitt's horizontal decorations can also be read as landscapes—bands of light or water or quivering air that can evoke a sense of place as succinctly as some of the more representational works in the collection.

Dr. McLaughlin has been selective, rather than encyclopedic, in assembling his holdings. The history of art in Connecticut begins before the Revolutionary War and includes artists working in every period and style, but availability and personal taste have, as a matter of course, played a role in shaping this collection.[7] Many of Connecticut's best-known painters—Ralph Earl, John Brewster, Frederic Church, John Haberle, Willard Metcalf, John H. Twachtman—have become familiar figures in American art circles, their works desired by collectors and museums nationwide, their prices constantly on the rise. Dr. McLaughlin has accepted their status and also realized that they represent only a small fraction of the artists who created notable images of the region. In terms of style and subject matter, Dr. McLaughlin is more interested in academically trained painters than in folk or outsider artists and more intrigued by landscape than portraiture or still life, though his recent acquisitions of the figurative Beckwith and a haunting still life of a rose by the realist Graydon Parrish (whose Connecticut connections come through his commissions rather than his residence) may hint at a future shift in strategy. Although the region's painters recorded both pastoral and industrial motifs, the landscapes in the collection emphasize the former, reflecting a reverence for nature rather than technology. But these choices, whether made deliberately or unconsciously, give the McLaughlin collection a definitive personality and spirit that another more generic or wide-ranging collection would lack. The soul of this collection lies in its reverence for place, in its desire to make connections between specific locations past and present and between the physical world and its spiritual associations.

It is this idea of place, of rootedness, and of meditation that links these diverse works. They have been gathered with an eye for the natural beauty of Connecticut and for the respite that beauty can offer to those willing to receive it. Through the medium of art, the actual landscapes are transformed beyond their physical appearance; the viewer sees beloved sites that are both real and ideal. Through these pictures, one can find relief in that other, more tranquil realm. As the poet Stevens observed of the Connecticut landscape that surrounded him, in these places one has a sense of restoration and return, a feeling of "coming home to the American self."[8]

Select Bibliography

French, H. W. *Art and Artists in Connecticut.* Boston: Lee and Shepard, 1879.

Notes

1. My own affection for Connecticut comes from my mother, Marilyn Nair Hirshler, who grew up in New Britain at 81 Columbia Street and at 35 Park Place. She, along with her sister Zecille Nair Gebhardt, gave me their memories of family and place. I would like to dedicate these words to my mother and to the Nair and Rokaw families, who, once upon a time, were such an integral part of New Britain.
2. Wallace Stevens, "Connecticut Composed," script for *This Is America* radio series, April 1955, quoted in Stevens, "This Is Connecticut," *Hartford Courant,* July 21, 1955, p. 12.
3. Ibid.
4. French, *Art and Artists in Connecticut,* p. 1.
5. Asher B. Durand, "Letters on Landscape Painting, No. VIII," *Crayon* 1 (June 6, 1855): 354.
6. See David Slater, "The Fount of Inspiration: Minnie Clark, the Art Workers' Club for Women, and Performances of American Girlhood," *Winterthur Portfolio* 39, no. 4 (Winter 2004): 229–58.
7. For a helpful modern survey of the subject, see Amy Kurtz Lansing, "The Artistic Heritage of Connecticut," *American Art Review* 19 (November–December 2007): 158–65, 167–68.
8. Stevens, "Connecticut Composed."

The Collection

James Carroll Beckwith (1852–1917)
Portrait of a Lady
(*Study of Minnie Clark*)
Oil on canvas, 22 x 18 in.
Signed (lower right): *Carroll Beckwith*

Bruce Weber
Senior Curator
19th and Early 20th Century Art
National Academy Museum
New York, New York

Born in Hannibal, Missouri, a few streets away from Mark Twain's former home, James Carroll Beckwith first studied at the Chicago Academy of Design and later at the National Academy of Design in New York. From 1873 to 1878 he studied in Paris at the Académie Suisse and the École des Beaux-Arts as well as at the atelier of Carolus-Duran along with John Singer Sargent, with whom he shared a studio for several years. After returning to America, Beckwith became a leading figure in the New York art world. He exhibited widely, was a close friend of leading American artists of his day, and was an influential teacher at the Art Students League.

Minnie Clark (née Mary Elizabeth Clark) was a popular model in New York in the 1890s,[1] posing for Charles Dana Gibson, William Merritt Chase, Thomas Wilmer Dewing, William T. Smedley, and A. B. Wenzell, among others. American artists were captivated by her classical looks—high cheekbones, delicately sculpted nose, azure eyes, pale, luminous skin—and her air of innocence and refinement. As Chase put it, she had "a clear cut classic face with splendid profile—a steadfast expression of sweetness, loveliness, womanliness—and above all else, dignity and simplicity."[2]

Beckwith considered Minnie the finest model he ever saw[3]—high praise from an artist who believed that models could be a great inspiration.[4] He felt that the "first requisite of a young female model is undoubtedly her face. It must be something fine, sentimental [and] nice to copy. A face that is really charming, that has individuality, does away with the need of invention on the artist's part, and it suggests ideas. Contrary to the general impression in the lay mind, the face is the fortune, and the figure comes afterward."[5]

Minnie frequently sat for Beckwith from 1890 to 1898. He first hired her in early March 1890, when he painted an oil of her wearing a wreath of roses on her head. She modeled for him at his studio in the Sherwood Building on West Fifty-seventh Street in Manhattan and at his country cottage in Onteora, New York. She came up to the Catskills to pose so often that she became a familiar fixture of the community. Beckwith and his wife, Bertha, considered her a member of the family and hosted her wedding to Percy Griffith at their cottage in September 1899. Beckwith's diaries mention her regularly throughout the 1890s, when he portrayed her in oil, pencil, charcoal, and pastel.

Portrait of a Lady is related to Beckwith's charcoal and pastel *Portrait of Minnie Clark* (Brooklyn Museum) and to his chalk and pastel *The Veronese Print* (Metropolitan Museum of Art, New York). The three works were probably executed in close succession in the late 1890s. In these pictures, Minnie poses with a sense of confidence and ease, wearing the same hairstyle and black dress. The oil emphasizes her radiant complexion, her soft wavy hair, and the shimmering textures and glowing transparencies of her clothing. She is seated in one of the Viennese bentwood chairs designed and produced by Michael Thonet, which became well known for their brilliant simplicity of design, economy, and durability. Beckwith's oil studies were praised by the art critics of the day for their intimacy, freshness, quality of spontaneity, and freedom of expression. A writer for the *New York Evening Post* found "him most likeable in the little studies, nudes, interiors, anecdotes. Here his cleverness seems most in place, and here he reveals a range of expression . . . somewhat surprising to those who know him chiefly as a portraitist."[6]

SELECT BIBLIOGRAPHY
Franchi, Pepi Marchetti, and Bruce Weber. *Intimate Revelations: The Art of Carroll Beckwith (1852–1917)*. New York: Berry-Hill Galleries, 1999.

James Carroll Beckwith Diaries, 1871–1917. Archives, National Academy Museum and School of Fine Arts, New York; microfilm, Archives of American Art, Smithsonian Institution, Washington, D.C., nos. 800 and 4798–4803.

James Carroll Beckwith Diary, 1895. New-York Historical Society.

James Carroll Beckwith Scrapbooks. New-York Historical Society.

Notes
1. On Clark's career as a model, see David Slater, "The Fount of Inspiration: Minnie Clark, the Art Workers' Club for Women, and Performances of American Girlhood," *Winterthur Portfolio* 39, no. 4 (Winter 2004): 229–58. For the most in-depth study of Beckwith's art and career, see Franchi and Weber.
2. William Merritt Chase, "How I Painted My Greatest Picture," *Delineator* 72 (December 1908): 969.
3. Beckwith Diaries, May 19, 1892.
4. Ibid., May 26, 1892.
5. "Artists' Models," *Art Amateur* 33 (September 1896): 70.
6. "The Beckwith Sale," *New York Evening Post*, April 10, 1910.

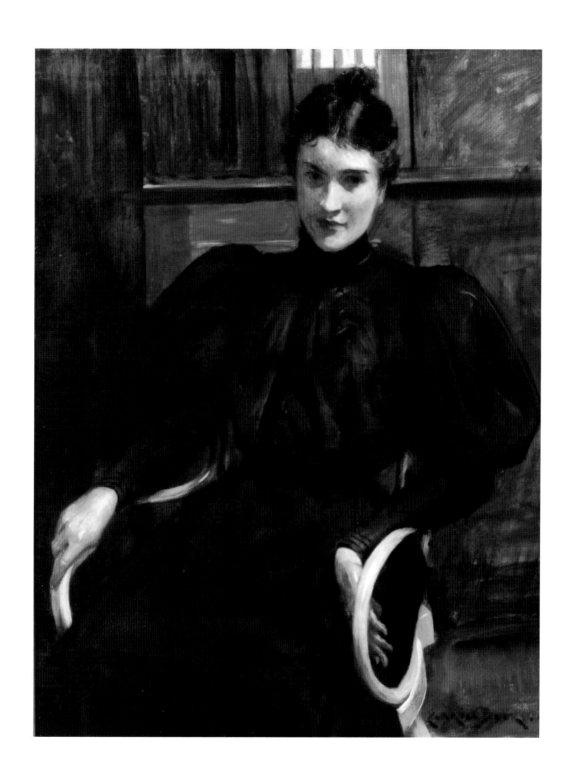

William Chadwick (1879–1962)
Millstone Point
Oil on canvas, 24 x 30 in.
Signed (lower right): *W. Chadwick*

Jillian Richard
Curatorial Intern
New Britain Museum of American Art

William Chadwick was born in England and moved to America with his family at the age of three, settling in Mount Holyoke, Massachusetts. The son of a textile manufacturer, he enjoyed the social privileges and domestic stability of an upper-class Victorian household.[1] Chadwick was encouraged to develop his artistic skills after exhibiting talent in drawing and painting as a child and enrolled at the Art Students League in New York following his high school graduation. There, he studied with many of the leading instructors of the day, including John H. Twachtman and Joseph DeCamp, members of the Ten American Painters, a select group of artists who held exhibitions annually from 1898 to 1906. Chadwick became acquainted with the basics of Impressionism at the Art Students League while also investigating more traditional, academic methods.[2]

Chadwick quickly adapted to the Impressionist style and the notion of painting outdoors. While enrolled at the Art Students League, he spent his summers at the favorite art colony of the American Impressionists, in Old Lyme, Connecticut.[3] He began to experiment with landscape painting, departing from his earlier figural subjects and portraits. Chadwick remained at the League until 1905, taking a brief trip to Rome in 1901. An extended sojourn in Europe in 1912 afforded him the ability to study in Paris, home of the leading Impressionist style. Forced to flee the city during summer 1914 due to the threat of war, he settled in the established art colony at Saint Ives in Cornwall, England, where he continued to paint in the plein air method. His preoccupation with landscape continued following his return to America in 1915, when he moved to Old Lyme. Chadwick sought out rural American landscape scenes to capture with his loose, Impressionist brushstrokes. While he did not eliminate figures from his work, his attention to landscape suggests that he regarded himself as a landscape painter.

Impressionism came late to America. It had been established in Paris in the 1870s as an alternative to the French academic manner. The Impressionists preferred sunlight to shadows; light, air, and color as experienced outdoors; and the fleeting daily scene as opposed to mythological or historical subjects. Artists strove to render not the landscape itself but the sensation it produced. While the French Impressionists depicted middle- and working-class subjects, the American Impressionists focused on sophisticated society and picturesque views of nature. The differences arose from America's emergence as a world power at the turn of the twentieth century, newly rich and recently influential.

Chadwick's style clearly reflects the changes occurring in American Impressionism at the time. The artist's fascination with Impressionistic landscape is evident in *Millstone Point*, which embraces the spontaneous quality of the style. The picture disregards traditional hierarchies of subject, order, and finish, capturing instead a snapshot, as waves smash against the rocky shoreline. Chadwick's bright palette is complemented by his quick, light brushstroke. Millstone Point is located on a former quarry in Waterford, Connecticut, and presently is the location of the only nuclear power plant in the state.

SELECT BIBLIOGRAPHY
Gerdts, William H. *Masterworks of American Impressionism from the Pfiel Collection.* Alexandria, Va.: Art Services International, 1992.

McCain, Diana Ross. *Connecticut Coast: A Town-by-Town Illustrated History.* Guilford, Conn.: Globe Pequot, 2009.

Peters, Lisa N. *Visions of Home: American Impressionist Images of Suburban Leisure and Country Comfort.* Carlisle, Pa.: Trout Gallery, Dickinson College, 1997.

Notes
1. Peters, *Visions of Home*, p. 58.
2. Gerdts, *Masterworks*, p. 87.
3. Ibid.

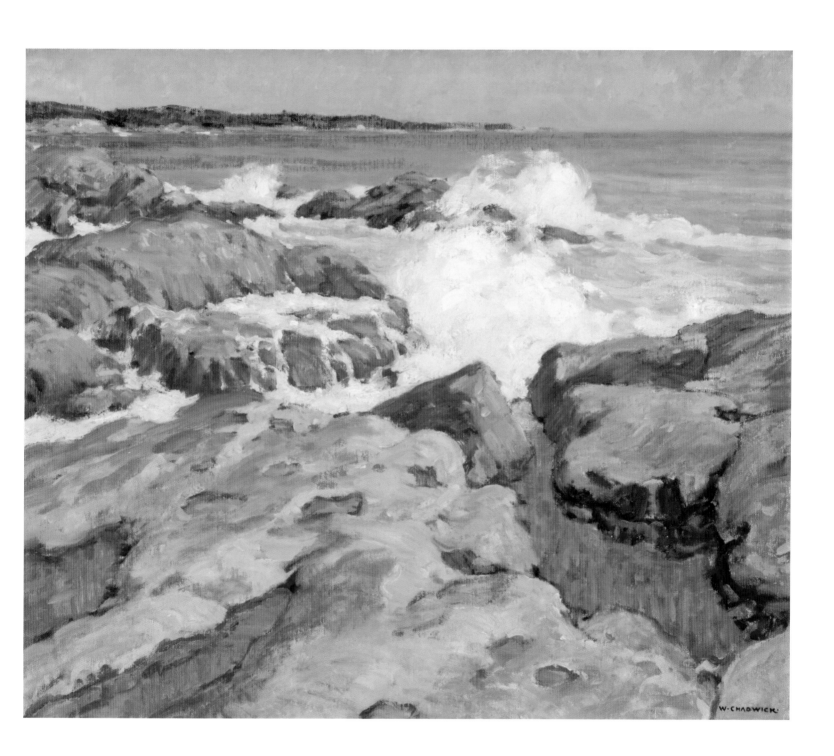

Bruce Crane (1857–1927)
May Moon, 1907
Oil on canvas, 22 x 30 in.
Signed (lower left): *Bruce Crane* 1907

Alexander J. Noelle
Assistant Curator
New Britain Museum of American Art

Crane was one of the nation's leading landscape painters and became internationally known for his Tonalist "American Barbizon" compositions. His idyllic landscapes were widely sought, and Crane was among the most awarded artists of his day, both nationally and internationally. Growing up in New York City with an amateur-artist father, it is no surprise that Crane regularly visited museums and galleries before his family moved to Elizabethtown, New Jersey, in 1874. While working at an architect's office, Crane took a summer trip to the Adirondack Mountains, where he stumbled upon a group of ladies sketching nature studies.[1] Inspired, he decided to pursue an artistic career and sought out the renowned artist Alexander Wyant as his mentor. Despite his Hudson River School training, Wyant admired the French Barbizon artists and developed a more painterly and personal response to nature; his Impressionist and Tonalist tendencies deeply influenced Crane.[2] Wyant and Crane only spent two months together, studying in the Adirondack and Catskill Mountains, but remained close friends until Wyant's death in 1892.[3]

During his time at the Easthampton, New York, art colony in the late 1870s and early 1880s, Crane won critical acclaim for his paintings of apple trees, hayfields, and farmyards. Unsatisfied with his success, however, he spent summer 1882 at the French art colony at Grez-sur-Loing studying with the Tonalist Jean-Charles Cazin, who introduced him to the subtle nuances of light and color as well as the technique of painting from memory.[4] Crane was drawn to the muted colors and subjective approaches of the Barbizon painters and incorporated many of their key elements into his work upon his return to New York.

While Crane always kept his studio and home in Bronxville, New York, he began making regular trips to the Old Lyme, Connecticut, art colony about 1902. That year, the Tonalist Henry Ward Ranger urged artists to join him in the "American Barbizon" and the Lyme Art Colony was founded. Crane did not, however, become an active, exhibiting member until nearly twenty years later.[5] During his summer visits, he found inspiring subject matter in the woods, meadows, and hills, and made studies that he developed into finished paintings upon his return to the studio.[6] In his later career, Crane became something of a permanent fixture at the colony and, despite his reputation as a loner, thrived in the company of his fellow artists.[7] Due to a hip injury, he spent the last two years of his life confined to his home and studio, though he continued to paint until days before his death.[8]

May Moon is an excellent example of Crane's evolving Tonalist style. The use of delicate tonal values and harmonies, muted colors, and a restrained composition are typical of the American Tonalist style. Aiming to evoke the quieter side of nature, Crane and the other Tonalists captured the serenity and nuances of light and tone in a carefully created harmony.[9] The Tonalists were concerned with conceptual truths based on a personal response to the landscape and frequently sacrificed the actual details of a scene to maintain the line, color, beauty, and mood of the final painting.[10] In *May Moon* the cherry tree at the right blossoms in front of the house, indicating that it is spring. Above, the full moon casts a soft glow, illuminating the pile of hay at the left. The inclusion of hay, a fall phenomenon, might be an addition meant to maintain the harmony of the image. *May Moon* does not represent an actual locale but rather an "unidentifiable pocket of nature."[11] The Tonalist canvas not only synthesizes various recollections in order to create a poetic mood and composition but also evokes a quiet moment of nature that inspired the artist's creative sensibilities.[12]

SELECT BIBLIOGRAPHY

Andersen, Jeffrey W. "Foreword." In Florence Griswold Museum, *Bruce Crane*, p. 3.

Andersen, Jeffrey, and Hildegard Cummings. *The American Artist in Connecticut: The Legacy of the Hartford Steam Boiler Collection.* Old Lyme, Conn.: Florence Griswold Museum, 2002.

Clark, Charles Teaze. "The Touch of Man: The Landscapes of Bruce Crane." In Florence Griswold Museum, *Bruce Crane*, pp. 4–15.

Florence Griswold Museum. *Bruce Crane (1857–1937): American Tonalist.* Old Lyme, Conn.: Lyme Historical Society and Florence Griswold Museum, 1984.

Lefebvre, Judith. *Connecticut Masters: The Fine Arts and Antiques Collections of the Hartford Steam Boiler Inspection and Insurance Company.* Hartford: Hartford Steam Boiler Inspection and Insurance Company, 1991.

Muir, Mary. "Bruce Crane: Tonal Impressionist." In Florence Griswold Museum, *Bruce Crane*, pp. 18–26.

Notes
1. Clark, "Touch of Man," p. 4.
2. Ibid., p. 5.
3. Andersen and Cummings, *American Artist*, p. 34.
4. Clark, "Touch of Man," p. 8.
5. Crane's participation in an Old Lyme exhibition is first recorded in 1919; see Andersen and Cummings, *American Artist*, p. 34.
6. Muir, "Bruce Crane," p. 22.
7. Clark, "Touch of Man," p. 4.
8. Like *May Moon*, his final painting, *A Romance* (1937; whereabouts unknown), depicted a misty night vista; see ibid., p. 14.
9. Andersen, "Foreword," p. 3.
10. Muir, "Bruce Crane," pp. 20–22.
11. Crane rarely painted scenes that existed or were easily recognizable; see Andersen and Cummings, *American Artist*, p. 34.
12. Muir, "Bruce Crane," p. 25.

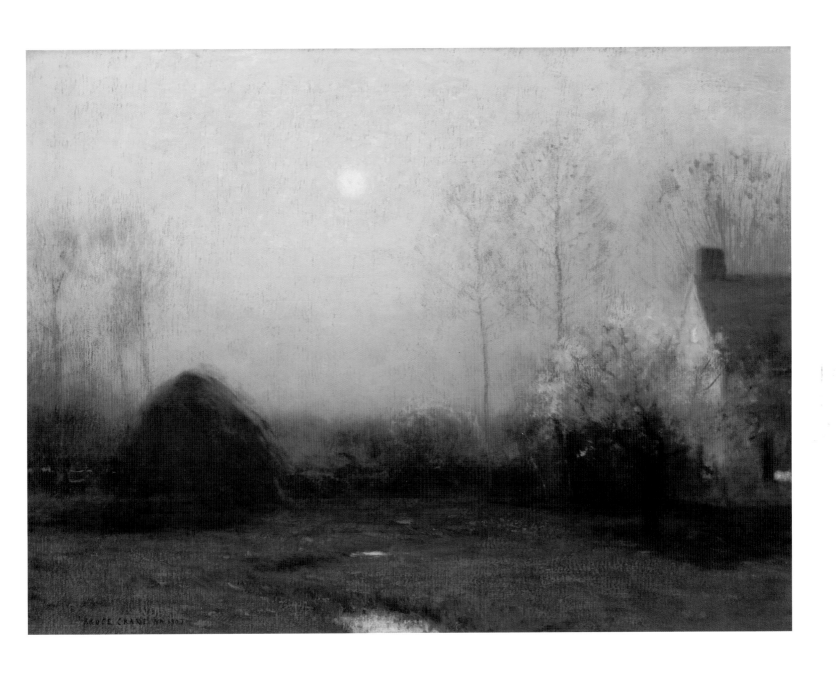

Asher B. Durand (1796–1886)
Landscape with Cattle, 1861
Oil on canvas, 10 x 16 in.
Signed (lower left): *AB Durand 1861*

Linda S. Ferber, Ph.D.
Senior Art Historian
New-York Historical Society

The Civil War had begun when Asher B. Durand portrayed the pastoral delights of the northern countryside in *Landscape with Cattle.* The artist was then sixty-five, on the brink of his late career, and a pillar of the artistic establishment. He was president of the National Academy of Design and acknowledged as the founder of the Hudson River School along with his friend Thomas Cole. The year 1861 was pivotal for Durand; he resigned the National Academy presidency after sixteen years of service and from then on, though he painted regularly, exhibited less often. He left New York City in 1869, retiring to a studio house on family property at Maplewood, New Jersey, where he continued to paint for almost two decades. He died there at the age of ninety, still a revered figure in American art, even though the power of the Hudson River School had waned by then—before the popularity of Barbizon and the rise of Impressionism.

Landscape with Cattle represents the quintessential embodiment of Durand's pastoral visions—panoramic and light-filled compositions developed in the 1840s after his return from a year of study in Europe. These polished, bucolic works reflected the artist's deep understanding of and admiration for Dutch and Flemish paintings as well as Claude Lorrain and John Constable. They take the form of monumental exhibition pictures of American scenery, such as *Hudson River Looking toward the Catskills* (1847; Fenimore Art Museum, Cooperstown, N.Y.), as well as more intimate cabinet paintings

such as this one. Refined over the decades in myriad variations, these signature landscapes were—and still are—perennial favorites among American patrons. Durand discussed the aesthetic appeal and therapeutic power of the pastoral landscape in the "Letters on Landscape Painting" (1855). He explained that the quiet contemplation of such "faithful landscapes" by the "merchant and capitalist" would inspire "pleasant reminiscences and grateful emotions" causing "care and anxiety [to] retire far behind him."[1]

The distant panorama in *Landscape with Cattle* undoubtedly signifies the Hudson, but a precise topographical identification eludes us. Indeed, the view may be an amalgam of scenes and sites drawn from studies made perhaps near the Highlands or closer to the Tappan Zee.[2] Clearly defined shadows cast by the trees and cows in the foreground are characteristic of Durand's compositions, as are the eroded banks, the stately trees with massive green crowns, the low horizon, and the broad expanse of luminous sky. These deftly realized natural and environmental features lend conviction to Durand's imagined world—a "faithful landscape" true to the familiar terrain of the Hudson River School. A well-traveled, tree-shaded country road beckons us and our bovine companions into an unblemished domain of rural harmony and peace, a realm that must have seemed especially poignant and alluring during the troubled times of 1861.

SELECT BIBLIOGRAPHY
Ferber, Linda S., ed. *Kindred Spirits: Asher B. Durand and the American Landscape.* New York and London: Brooklyn Museum with D Giles Limited, 2007.

Ferber, Linda S., ed. *The American Landscapes of Asher B. Durand (1796–1886).* Madrid and New York: Fundación Juan March with the New-York Historical Society, 2010.

Notes
1. Cited in Rebecca Bedell, "'Nature Is a Sovereign Remedy': Durand and the Absorptive Landscape," *New-York Journal of American History* (2007): 83.
2. My thanks to Robert Henshaw, managing editor of the Hudson River Environmental Society, for speculating with me about possible sites along the Hudson River for *Landscape with Cattle.*

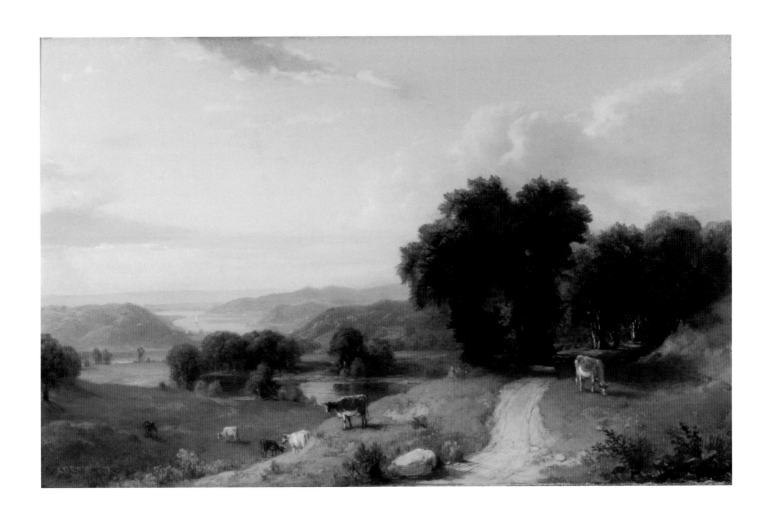

Ben Foster (1852–1926)
The Meeting House
Oil on canvas, 30 x 30 in.
Signed (lower left): *Ben Foster*

Blair Apgar
Curatorial Intern
New Britain Museum of American Art

At the turn of the century, Ben Foster bought a house in Cornwall Hollow, Connecticut. His new home would prove to be both a sanctuary from his life in New York and, from the 1890s until his death in 1926, a major source of inspiration. Foster typically chose views within fifteen miles of Cornwall Hollow, often painting nocturnes and woodland scenes. Poetic in aspect, his pictures contain sterling qualities of color, drawing, and composition.[1]

Foster was an accomplished artist; he won numerous medals for his landscapes and his paintings were collected by major museums. According to legend, the commissioner of art for the French government, who selected works to be purchased and hung at the Musée du Luxembourg, walked through a gallery at the Paris Exposition Universelle of 1900, where Foster's work was on display. He dismissed all of the paintings on view—grand scenes of European life and landscape— stopping only to inspect an intimate depiction by Foster of a small New England village. The commissioner was so taken with the picture that he immediately acquired it on behalf of the French government.[2]

The Meeting House is an exceptional example of a Connecticut landscape by the artist and atypical of his work in the genre, in that it includes a building. The structure at the far left is likely Cornubia Hall, a Baptist church that could be seen from his property.[3] A strong sense of intimacy is evident in the scene, one that Foster had painted several times

before. In the Barbizon style, the landscape is picturesque and calm, depicting the subtle transition between day and night.[4] The remaining sunlight appears in the sky, but the stream reflects darker tones, as if a cloud were passing by or the sun were about to set over the edge of the mountain. This attention to changing light was typical of the American Barbizon artists, who painted their personal interaction with, and response to, nature rather than a literal depiction of the landscape. They typically avoided scenes with bright sunlight and instead opted for vistas with varied light and shadow.

The composition of *The Meeting House* appears to be symmetrical, but, upon closer inspection, small nuances become apparent. Even though the stream bisects the landscape, it is positioned slightly off-center, as is the mountain. Foster included the imperfections of the natural landscape and, in a way, cultivated its inherent tranquility. The tones are predominantly warm, as if reflecting the yellows, oranges, and reds of the impending sunset. The brushstrokes are loose, held together by differentiating tones, particularly in the grassy plain to the right of the stream. While the brushstrokes are not as free form as they would become in the imminent Impressionist style, they were an important component of Foster's attempt to generate an emotional response through landscape. The artist typically completed his canvases from memory back in the studio, which allowed him to idealize them, blending reality with imagination and creating an almost poetic harmony.[5]

SELECT BIBLIOGRAPHY
Austin, Robert Michael. *Artists of the Litchfield Hills*. Waterbury, Conn.: Mattatuck Historical Society, 2003.

Notes
1. American Art Association, *Catalogue of American Paintings Belonging to William T. Evans* (New York: I. J. Little & Co., 1900), p. 33.
2. Alice Sawtelle Randall, "Connecticut Artists and Their Work: Ben Foster, a Painter, Who While a Native of Maine, Receives Much of His Inspiration from the Connecticut Hills," *Connecticut Magazine* 9 (1905): 141–42.
3. Austin, *Artists*, p. 33.
4. Ibid., p 31.
5. Randall, "Connecticut Artists," p. 143.

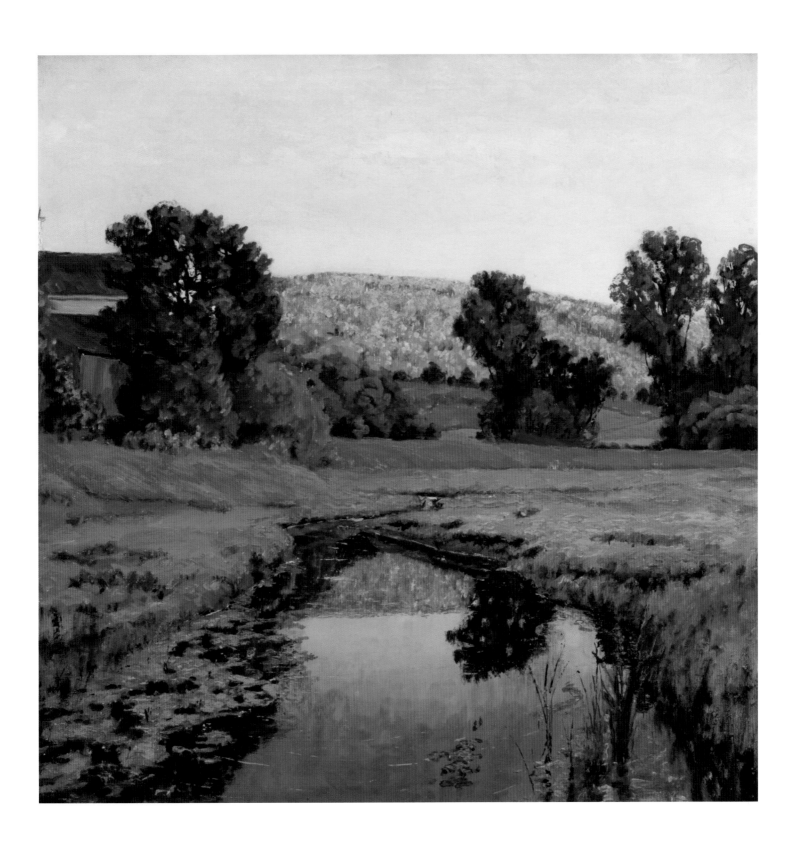

Sanford Robinson Gifford (1823–1880)
Hudson River Highlands, ca. 1867
Oil on canvas, mounted on board, 5½ x 10 in.

Kevin J. Avery
Associate Curator
American Paintings and Sculpture
The Metropolitan Museum of Art
New York, New York

Along with John Frederick Kensett, Jasper Francis Cropsey, and Samuel Colman, Sanford Robinson Gifford was one of the relatively few Hudson River School painters who actually painted the Hudson frequently as well as memorably. Undoubtedly, that was at least in part because he was raised on its shores, at Hudson, New York, and throughout his life made regular visits home—either via steamship or on the train that ran along the river's eastern shore—from his atelier in the Tenth Street Studio Building. His images of the Hudson, ranging from the estuarial boundary of his hometown all the way down to New York City, are concentrated in the mid-1860s and late 1870s. Although *Highlands of the Hudson* has been associated with the later decade, Gifford worked in such a consistent style from the late 1850s on that this view might well have been done as early as 1863, when he produced *A Picnic Party on the Highlands of the Hudson* (whereabouts unknown).[1] Just a few years later he would exhibit views of Hook Mountain and High Tor, on the west bank of the Hudson not far south of the Highlands.

This view appears to be northwest from Constitution Island, located off the east bank of the river just across from West Point.[2] At the left is Storm King Mountain; at the right (from left to right) are Breakneck Ridge and Mount Taurus. The latter is so modeled by the mild early morning light

that it conveys the impression of two hills. At the foot of Taurus is Little Stony Point, a peninsula of the east shore. In the far distance upriver is the terrain of New Windsor and Newburgh, where the river bends north, but Gifford has considerably exaggerated the altitude and contour even more than he has the height of the mountains in the middle distance. In so firmly enclosing the prospect, the artist may have been recalling his earlier views of Alpine lakes—Geneva and Maggiore, for example, executed during and after his first trip to Europe, in 1855–57.[3] In those pictures, loftier, snowbound peaks form an unbroken foil for the still, reflecting waters and the vessels borne by them. In *Highlands of the Hudson,* the artist plotted the space of the river with several sloops and a steamer plying south in the distance near the eastern bank.

Although broadly and somewhat rapidly executed, the terrain in *Highlands of the Hudson* shares with most of Gifford's work the warm illumination, chromatic shadows, and softening scrim of atmosphere that have always made his paintings irresistible to collectors. As in many of his pictures, we can detect vestiges of his original graphite underdrawing (which he did not always follow faithfully with his brush) in the contours of the mountains immediately to the left and right of the river.

SELECT BIBLIOGRAPHY
Avery, Kevin J., and Franklin Kelly. *Hudson River School Visions: The Landscapes of Sanford R. Gifford.* New York and Washington, D.C.: Metropolitan Museum of Art and National Gallery of Art, 2003.

[Pratt, Waldo S.]. *A Memorial Catalogue of the Paintings of Sanford Robinson Gifford, N.A.* New York: Metropolitan Museum of Art, 1881.

Weiss, Ila S. *Poetic Landscape: The Art and Experience of Sanford Robinson Gifford.* Newark, Del.: University of Delaware Press, 1987.

Notes
1. [Pratt], *Memorial Catalogue,* p. 26, no. 294. The painting, reportedly dated May 22, 1863, measured 5½ by 8½ inches.
2. Constitution Island is now the property of the United States Military Academy at West Point, but tours are conducted there in summer by the Constitution Island Association. I wish to thank Richard De Koster, Executive Director, and Mrs. Emerson Pugh, Chair of the Board of Trustees of the Association, for inviting me to the island and supplying copies of photos and paintings of the view from its north shore. The view northwest from Constitution Island is also approximated on Google Earth: enter

"Constitution Island, New York," approximately 41°24'62" x 73°57', 14", elevation 0.
3. See, for example, *The Castle of Chillon* (1859; private collection) and *Lago Maggiore* (1854; Frances Lehman Loeb Art Center, Vassar College, Poughkeepsie), both illustrated in Avery and Kelly, pp. 107, 198.

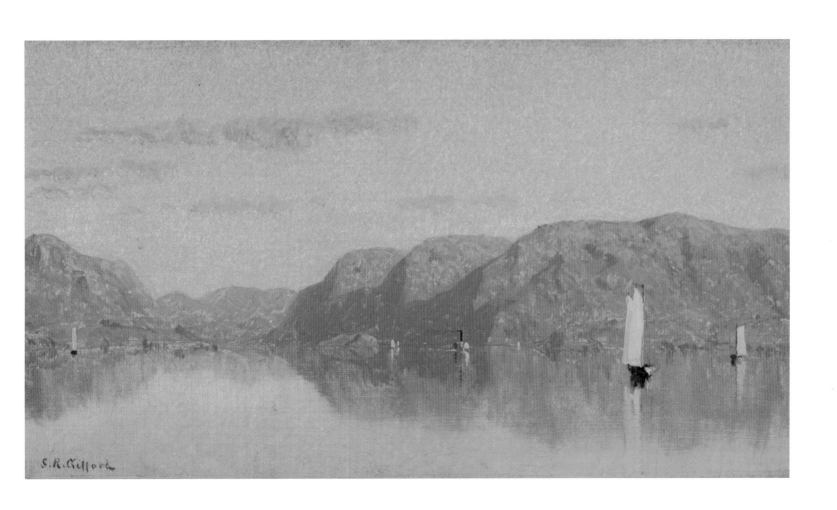

James McDougal Hart (1828–1901)
Farmington River
Oil on canvas, 14 x 22 in.
Signed and inscribed (lower left): *James M. Hart*
Farmington River Conn.

Christy Johnson
Curatorial Intern
New Britain Museum of American Art

James McDougal Hart was a member of a family of artists. Born in Scotland, he moved with his family to Albany, New York, while still a child. As a youngster, his talent for drawing and painting became apparent. In the early 1850s Hart studied in Germany at the Düsseldorf Art Academy, where his instructor Johann Schirmir greatly influenced Hart's realistic style. In 1857 he moved to New York City and opened a studio. James and his older brother, William, became famous for their pastoral landscapes and enjoyed success as professional artists. Their rural landscapes were admired by New Yorkers who viewed such works of art as a chance to "get away" from the hustle-bustle of the big city. Hart's work was exhibited in New York, Philadelphia, Boston, Chicago, Washington, D.C., and at the Paris Exposition Universelle of 1867.

Hart became a member of the National Academy of Design and was named vice president in 1859. Eventually, both he and William opened studios in Keene Valley, New York. Hart spent his time with his family when he was not in his studio—he tended to stay out of the public eye much more than other New York artists. The artist George William Sheldon, a contemporary of Hart's, described him as witty, hard working, good-natured, and trustworthy yet went on: "Some of the finest qualities that make a man prized in social life are to be found in James M. Hart; and why he has not been carried by them into social life is inscrutable, and, in many respects, to be regretted."[1]

The brothers and their sister, Julie Hart Beers, were part of the second generation of the Hudson River School, established by Thomas Cole in the early nineteenth century. In order to achieve realistic and sublime works, the artists made preliminary sketches outdoors. Hart said: "I strive to reproduce in my landscapes the feeling produced by the original scenes themselves. . . . If the painting were perfect, you would feel precisely as you feel when contemplating such a scene in Nature."[2] *Farmington River* is exemplary of his work. The river meanders through the left side of the composition and disappears in the trees, cloaked with the green leaves of a warm season. In the distance, the hills stretch for miles, drawing the viewer's gaze with them. Hart often included cattle in his scenes and, in 1871, began to study them more closely. Here, they roam free, grazing in the foreground.

With the growth of industrialization, many Americans were forced to move to the cities in order to find work. Paintings such as *Farmington River* gave these workers a chance to imagine what it would be like to be in a place unspoiled by man. Hart's painting does not make any reference to a societal establishment, choosing to ignore the presence of man.

SELECT BIBLIOGRAPHY

Driscoll, John. "Hart, James McDougal." In *Oxford Art Online*, http://www.oxfordartonline.com/subscriber/article/grove/art/T036775 (accessed May 18, 2010).

Sheldon, George William. *American Painters, with one hundred and four examples of their work engraved on wood.* New York: D. Appleton and Company, 1881.

Sullivan, Mark, James M., and William Hart. *American Landscape Painters.* New York: John F. Warren, 1983.

Tuckerman, Henry T. *Book of the Artists: American Artist Life Comprising Biographical and Critical Sketches of American Artists.* New York: J. F. Carr, 1967.

Notes

1. Sheldon, *American Painters*, p. 47.
2. Ibid.

Childe Hassam (1859–1935)
Fireplace in the Old House, 1912
Oil on cigar box panel, 5½ x 9 in.
Signed (verso): *Childe Hassam/1912*

Susan G. Larkin
Independent Art Historian
Greenwich, Connecticut

Hassam's small panel, painted on the lid of a Cuban cigar box, depicts a woman before the fireplace in the dining room of the boardinghouse in Cos Cob, Connecticut, that was the gathering place of a lively art colony at the turn of the twentieth century. Hassam was a frequent visitor from 1894 to 1918. The boardinghouse, owned and operated by Josephine and Edward Holley, was called the Holley House or simply The Old House. The latter name appears on the establishment's letterhead and in the title of several works by Hassam and other artists. (The Bush-Holley House, as it is known today, is part of the Greenwich Historical Society.)

Hassam produced at least six images of a woman beside a fireplace in the Holley House. Four of them represent the more elaborate Federal mantelpiece in the Best Bedroom. *Fireplace in the Old House* and the etching *The White Mantel* (1915), on the other hand, depict the simpler mantelpiece in the dining room, where artists and writers dined and debated politics and the arts.[1]

The sitter cannot be identified with certainty. Hassam relied on several models during his stays in Cos Cob, including his wife, Maud; Josephine Holley; her daughter Constant Holley MacRae; the artist Caroline Mase; and the teenager Helen Burke, whose father ran the tavern two doors from the Holley House. In all the images, the model has the same hairstyle but the color does not provide a clue: although Helen Burke had light brown hair, Hassam portrayed her as a redhead. It is even possible that the model was the novelist Willa Cather, who first visited The Old House sometime before 1915. The painting is not, however, a portrait. The willingness of the model to allow Hassam to depict her as she read in the glow of the fire was more important than her individuality. Of all the women Hassam portrayed before a fireplace, she alone is engaged in an activity; the others merely stand or sit. Her middy blouse and black skirt create a more casual mood than the pristine white dresses and flowered kimonos in the other images, as does her relaxed, natural pose.

Fireplace in the Old House is one of at least five small panels that Hassam painted during his stay at the Holley House in 1912. He titled three of them *The Fireplace.* One is most likely this work; another, now called *The Mantle Piece* (Greenwich Historical Society), depicts a woman thought to be the artist's wife in front of the fireplace in the Best Bedroom, as does another from that series, *The Fireplace* (private collection).[2] In 1913 Hassam sent three "fireplace" panels to the "16th Annual Exhibition, Ten American Painters" at Montross Gallery in New York, along with *Mrs. Holley of Cos Cob* (Mr. and Mrs. Charles M. Royce) and *The A-1 News Depot* (Florence Griswold Museum, Old Lyme, Conn.)

SELECT BIBLIOGRAPHY
Larkin, Susan G. *The Cos Cob Art Colony: Impressionists on the Connecticut Shore.* New Haven: Yale University Press with National Academy of Design, 2001.

Larkin, Susan G. "Hassam in New England." In H. Barbara Weinberg et al., *Childe Hassam: American Impressionist.* New York: Metropolitan Museum of Art, pp. 119–77.

Merrill, Linda, et al. *After Whistler: The Artist and His Influence on American Painting.* New Haven: Yale University Press with High Museum of Art, 2004.

Notes
1. The dining room mantelpiece was altered in 1957 and again in 1996. A photograph from Clarissa MacRae's photo album dated 1917 (Greenwich Historical Society, archives) shows the mantelpiece as it appears in *Fireplace in the Old House* and *The White Mantel.* I am grateful to the Greenwich Historical Society curator of collections Karen Frederick and the archivist Anne Young for their assistance in identifying the setting.
2. Reproduced in Larkin, *Cos Cob Art Colony*, p. 166.

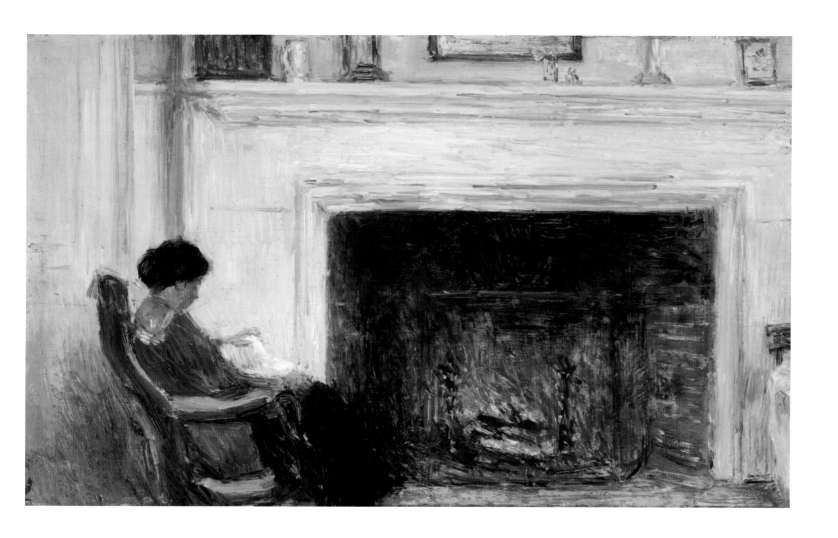

Robert Henri (1865–1929)
Untitled (*Nude with Arm over Head*)
Pen and ink on paper, 9 x 5¹/₂ in.
Signed (lower left): *Robert Henri*

Elizabeth Kennedy
Curator of Collection
Terra Foundation for American Art
Chicago, Illinois

The charismatic teaching of Robert Henri dominated New York's avant-garde artistic milieu at the turn of the century. He studied at the Pennsylvania Academy of the Fine Arts and at the Académie Julian and the École des Beaux-Arts in Paris, where life drawing of the nude formed the core of his training. Philosophically progressive in both art and life, Henri abhorred the conservatism inherent in art "academies" but was anxious to win the critical acclaim of prestigious art institutions. After the Luxembourg museum acquired one of his paintings at the Paris Salon of 1898, the ambitious American artist relocated to New York to become a champion of artistic individualism.

The essence of Henri's art philosophy was based on an individual's unique life experiences. As a result, he spent much of his energy bringing together artists of myriad styles by organizing independent exhibitions. The motivation for Henri's unstinting support of diverse artistic expression was to overcome the censoring, conservative juries of New York's best-known art institutions. He launched the careers of his closest friends by organizing the infamous 1908 exhibition of The Eight at Macbeth Gallery. The Eight's contemporaries celebrated the individuality of their unique artistic visions. A quarter of a century later, historians labeled the group as "realists," or, more specifically, as members of the Ashcan School, to distinguish them from academic or Impressionist painters.

Henri's appreciation of nonrepresentational art is less recognized but is clear through his association with Alfred Stieglitz. Both offered their imprimatur to the artists included in the "Exhibition of Independent Artists" of 1910 (often acknowledged as the prototype of the 1913 Armory Show). Without a doubt, Henri was familiar with the minimalist European drawings on display at Stieglitz's gallery 291, and his inquisitive mind would have appreciated their powerful simplicity.

Conceivably, Henri could have drawn this young model's shapely form with his eyes closed. The muscle memory that the artist developed from sketching hundreds of such drawings is embedded in the almost uninterrupted, flowing outline of her figure. Here, Henri departed considerably from his Pennsylvania Academy colleague Thomas Eakins, who explored the muscular reality of the body drawn from life. In truth, the modern pedigree of this delectable vision is closer to that of the French modernists Henri Matisse and Auguste Rodin, both famous for their drawings of the nude.

It is instructive to contrast Henri's appreciative rendering of the female nude with that of his near contemporary Childe Hassam. While Hassam's model demurely turns her back, her nakedness is emphasized by the aggressive strokes delineating the surrounding vegetation. There is nothing shy about Henri's scantily draped model, who directly invites the viewers to enjoy her attributes. By eliminating a background context or even a three-dimensional sense of her body through shading with the pencil, Henri, like other progressive artists, modernized the universal appeal of the female nude.

SELECT BIBLIOGRAPHY

Homer, William Innes. *Robert Henri and His Circle*. Ithaca: Cornell University Press, 1969.

Perlman, Bennard B. *Robert Henri: His Life and Art*. New York: Dover, 1991.

Vure, Sarah. "After the Armory: Robert Henri, Individualism, and American Modernisms." In Elizabeth Kennedy, ed. *The Eight and American Modernisms*. Chicago: University of Chicago Press, 2009, pp. 57–75.

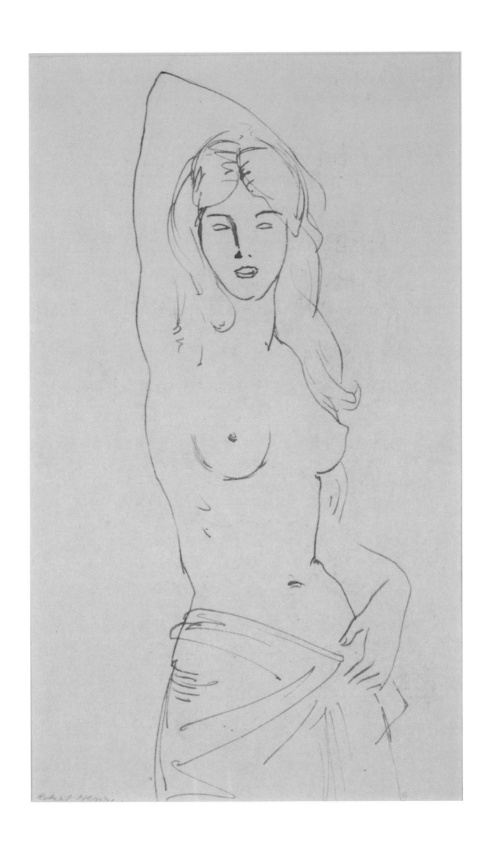

Wilson Henry Irvine (1869–1936)
Sunlight and Shadows, 1917
Oil on canvas applied to board, 24 x 27 in.
Signed (lower right): *IRVINE*

Wilson Henry Irvine liked to paint when there was "a kind of hazy beauty in the air."[1] *Sunlight and Shadows,* a depiction of a spring landscape in Lyme, Connecticut, is a perfect demonstration of the artist's preferences. A screen of slender trees is beginning to blossom with spring green and orange-red foliage. Just beyond, the hillside opens up to a vista over the hills of Lyme. While the trees cast soft shadows in the foreground, the entire landscape is bathed in the glowing atmospheric light typical of a New England spring.

A Midwesterner by birth, Irvine was prominent in Chicago art circles early in his career. He belonged to the Cliff Dwellers and served as president of the Palette and Chisel Club and the Chicago Society of Artists. Although he did not move to Connecticut until toward the end of World War I, he made periodic visits to New England beginning as early as 1905–6. While still living in Chicago, he painted at various locales ranging from Connecticut to Cape Ann to the Maine Coast, where he favored Monhegan Island. Irvine and his family first came to Lyme in 1914, spending the first of four summers there. In 1918, a year after he painted *Sunlight and Shadows,* he bought a home in the Hamburg Cove section of Lyme and settled there permanently. He continued traveling

Jeffrey W. Andersen
Director
Florence Griswold Museum
Old Lyme, Connecticut

extensively, painting abroad in Cornwall, England, and in France and Spain. However, he always returned to Lyme to record his response to the seasonal nuances and changing light of the Connecticut landscape.

Although remembered today as an American Impressionist landscape painter, Irvine produced an extensive body of work that reveals his experimental nature. Beginning about 1927, he initiated a series of what he called "aquaprints" in which he tried to control the process of making marbleized paper to suggest landscape or figural motifs. The resulting prints tend to be more abstract than his paintings. Then, in 1929, he began a series of "prismatic" paintings in which he recorded the optical effects of subjects viewed through a prism. The resulting pictures show halos of refracted light surrounding the edges of his still lifes and figural subjects. The critics were not particularly impressed, one asserting that Irvine was "tipsy with prism madness."[2] But, as art historian Harold Spencer has since pointed out, "His prismatic paintings were intense explorations of the nature of light."[3] Indeed, that search for the specific qualities of light and atmosphere in his subjects is one of the hallmarks of Irvine's art.

SELECT BIBLIOGRAPHY
Gordon, Cheryl Cibulka. *Explorations of an American Impressionist: The Art of Wilson Irvine, 1869–1936.* Washington, D.C.: Adams Davidson Galleries, 1990.

Spencer, Harold. *Wilson Henry Irvine and the Poetry of Light.* Old Lyme, Conn.: Florence Griswold Museum, 1998.

Spencer, Harold, Susan Larkin, and Jeffrey W. Andersen. *Connecticut and American Impressionism.* Storrs, Conn.: William Benton Museum of Art, 1980.

Notes
1. Statement attributed to Irvine in Florence Davis, "The Artists' Velvet Tie Gives Way to Hip Boots," *Detroit News,* March 16, 1924. Wilson Irvine Papers, Archives of American Art, Smithsonian Institution, Washington, D.C., microfilm reel 1233, frame 160.
2. Edward Alden Jewell, "The Summer Art Season Maintains Its Zestful Stride," *New York Times,* August 4, 1929.
3. Spencer, *Wilson Henry Irvine,* p. 43.

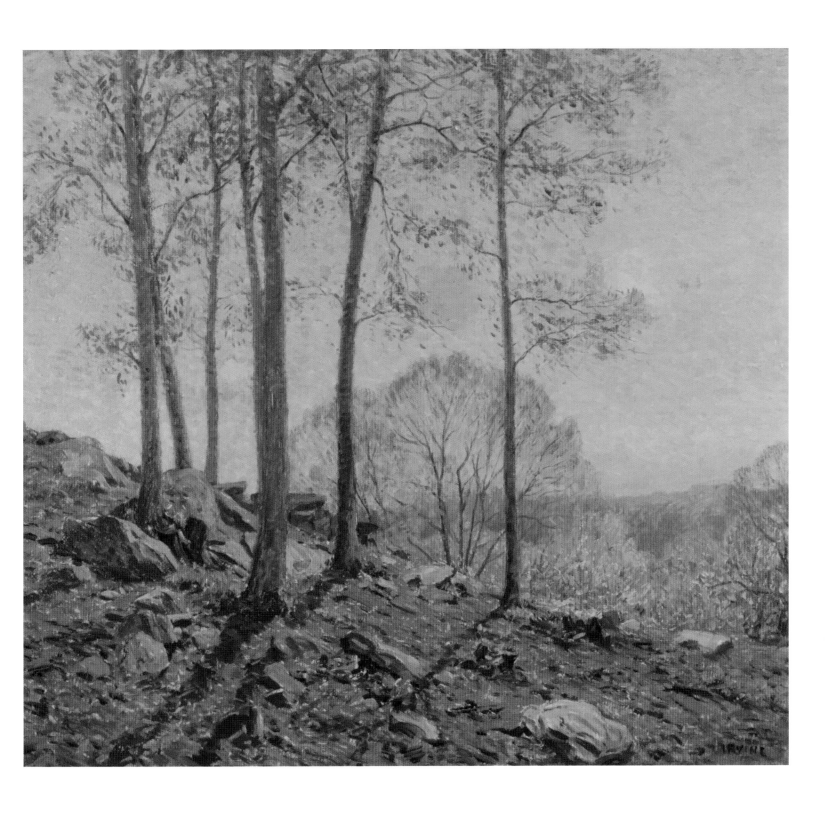

Wolf Kahn (b. 1927)
Richard Hamilton Barns, 2006
Pastel on paper, 11 x 14 in.
Signed (lower center): *Wolf Kahn*

Carole Jung
Curatorial Intern
New Britain Museum of American Art

Wolf Kahn has been referred to as "a minor master, or even a major minor master."[1] As a child, he was encouraged by both his paternal and maternal grandparents to pursue his interest in art. Kahn left Nazi Germany for England in 1939 and a year later immigrated to the United States, where he was reunited with his family. After graduating from the High School of Music and Art in New York, he enrolled at the New School for Social Research, where he studied painting with Stuart Davis (1892–1964) and printmaking with Hans Jelinek (1910–1992), and subsequently attended the Hans Hofmann School of Fine Arts. Hofmann (1880–1966) was of the opinion that "art was a high calling reaching beyond the pale documentary critique of American regionalism or the polite semi abstraction which was the current approximation of modernism then being celebrated at the Whitney Annuals."[2]

In 1951 Kahn received his B.A. from the University of Chicago and soon after returning to New York co-founded Hansa Gallery (1952–59), one of the most important of the numerous cooperative galleries established during the postwar period. Even though Kahn's style is rooted in Abstract Expressionism, which was then at the height of its popularity, it remains representational.

Kahn concentrates on exploring composition and color by painting forests, fields, and barns *en plein air* yet maintains that his pictures are in fact not about those very same forests, fields, and barns but go beyond them, explaining that he wanted "to do Rothko over from nature."[3] Vivien Raynor, an art critic for the *New York Times,* has referred to Kahn's paintings as "chromatic arias."[4]

Kahn first depicted barns started in 1966 and continued to paint them throughout the 1970s and 1980s. He might have been inspired by sentimental poems about New England's red barns and covered bridges, such as those by Robert Frost and Archibald MacLeish. Kahn often paints the same barn from different angles, at different times of day, and at various scales to convey different meanings. This working method was most famously employed by Claude Monet (1840–1926) in his pictures of haystacks. When looking at *Richard Hamilton Barns* and Kahn's other paintings of the same structure seen from different angles, the viewer is able to imagine the appearance of the barn in its entirety. At the same time one is able "to understand Kahn's perceptions of his surroundings and the different methods he used to explore them."[5] Kahn feels that as a structure "the barn invariably has a much greater presence than the farmer's dwelling . . . our utilitarian buildings, erected without a self-conscious aesthetic, are most often superior to our domestic architecture."[6]

SELECT BIBLIOGRAPHY
Kahn, Wolf. *Pastel Light.* Station Hill Press, 1983.

Kahn, Wolf. *Wolf Kahn: Continuity and Change: Paintings and Works on Paper, 1958–66/2000–03.* New York: Ameringer Yohe Fine Art, 2003.

San Diego Museum of Art. *Wolf Kahn: Landscapes.* San Diego: San Diego Museum of Art, 1983.

Spring, Justin. *Wolf Kahn.* New York: Harry N. Abrams, 1996.

Notes
1. Annette Grant, "Portrait of the Artist's Market," *Art and Auction* (February 9, 2008).
2. Spring, *Wolf Kahn,* p. 16.
3. San Diego Museum of Art, *Wolf Kahn,* p. 9.
4. Vivien Raynor, "Three Artists and Expressions Sharing a Show," *New York Times,* August 11, 1996.
5. Art Institute of Chicago, "About this Artwork," http://www.artic.edu/aic/collections/artwork/73345/print (accessed May 6, 2010).
6. Wolf Kahn, "About Barns," unpublished ms., 1971, cited in Spring, *Wolf Kahn,* p. 65.

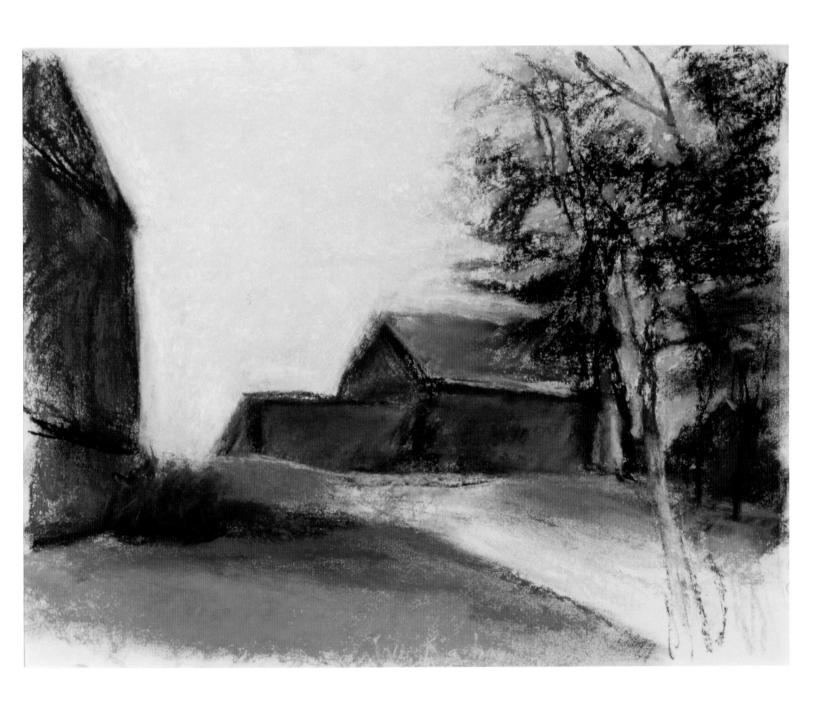

John Frederick Kensett (1816–1872)
A View in Italy, 1847
Oil on canvas, 23 7/8 x 35 7/8 in.
Signed (lower left): *JFK 1847*

Dr. Elizabeth Mankin Kornhauser
Chief Curator and Krieble Curator of
American Paintings and Sculpture
Wadsworth Atheneum Museum of Art
Hartford, Connecticut

In 1840, in an effort to advance his career, John Frederick Kensett went to Europe, where he spent seven and a half years studying, sketching, and painting as he traveled through England, France, the Rhine Valley, Switzerland, and Italy. He joined the community of American artists living abroad and visited major museums to study the paintings and drawings of Old Masters while honing his skills as a landscape painter.

In 1845 Kensett was finally able to afford to travel to Rome, where he attended classes and became a member of the local colony of American artists. At the time, he wrote of his ambition to paint scenes "for exhibitions at home, or for such travelers as may be disposed to purchase on the spot," and, indeed, it was there that he produced several major works that would establish his reputation upon his return to the United States in 1847.

In summer and fall 1846 Kensett and fellow painter Thomas Hicks began an extended tour of the picturesque regions of Albano, Lake Nemi, Subiaco, and Tivoli. Kensett returned to Rome with numerous sketches and oil studies that he used as inspiration for a series of paintings completed the following winter. *A View of Italy* resulted from this trip and is thought to be the work entitled *The Anio Scene near Subiaco, Italy* that Kensett exhibited in New York in 1848 at the National Academy of Design and the American Art-Union. It shows one of the views of Italy most recognizable to Americans—the stretch of aqueducts crossing the Roman Campagna just outside the walls of Rome. Built under Emperor Claudius in A.D. 52, the ancient aqueducts carried clean water from the surrounding mountains and stretched across forty-two miles,

from the Anio Novus River at Subiaco to Rome. Thomas Cole had earlier immortalized the aqueducts in such paintings as *Roman Campagna* (1843; Wadsworth Atheneum Museum of Art, Hartford), which depicts the famous ruins as a powerful symbol of the fallen empire.

Influenced by the fame of Cole's Italian views, which were based on Claudian models, Kensett's painting incorporates a clear division of space and strong contrasts of areas of light and dark. Scattered across the framed foreground, cast in shadow, are carefully delineated jagged rocks, reflecting the artist's love of the particular in nature. The pastoral middle ground, with a meandering path and stream, is illuminated, leading the eye toward the aqueduct and the mountain range beyond. Kensett included several figures in peasant garb, likely based on the many studies he made during life classes in Rome. The picture is related to another painting from this trip, *Italian Scene* (ca. 1847; Georgia Museum of Art, University of Georgia), which similarly includes a stretch of the aqueduct at center and a mountain range beyond. In *Italian Scene* Kensett's fascination with geology is conveyed by a large rocky promontory in the form of an anthropomorphic human facial profile rather than the jagged rocks in *A View of Italy.*

On November 3, 1847, Kensett left on a steamer for New York, where he received positive reviews and ready sales for his paintings of Italian scenery. His career would flourish as he turned his attention to the American landscape.

SELECT BIBLIOGRAPHY
Driscoll, John, and John K. Howat. *John Fredrick Kensett: An American Master.* New York and London: Worcester Art Museum with W. W. Norton, 1985.

Manoguerra, Paul, with Janice Simon. *Classic Ground: Mid-Nineteenth-Century American Painting and the Italian Encounter.* Athens, Ga.: Georgia Museum of Art, 2004.

Stebbins, Theodore E., Jr., et al. *The Lure of Italy: American Artists and the Italian Experience, 1760–1914.* Boston: Museum of Fine Arts with Harry N. Abrams, 1992.

Notes
1. Driscoll, *John Fredrick Kensett,* p. 49.
2. Kensett to Elizabeth Kensett, January 3, 1844;

quoted in ibid, p. 57.
3. Shannon's Fine Art Auctioneers, Greenwich, Conn., *Fine American and European Paintings, Drawings, and Sculpture,* April 24, 2003, lot 81.
4. Stebbins, *Lure,* p. 260.
5. Driscoll, *John Fredrick Kensett,* p. 58.
6. Manoguerra, *Classic Ground,* pp. 50–51.
7. Driscoll, *John Fredrick Kensett,* p. 61.

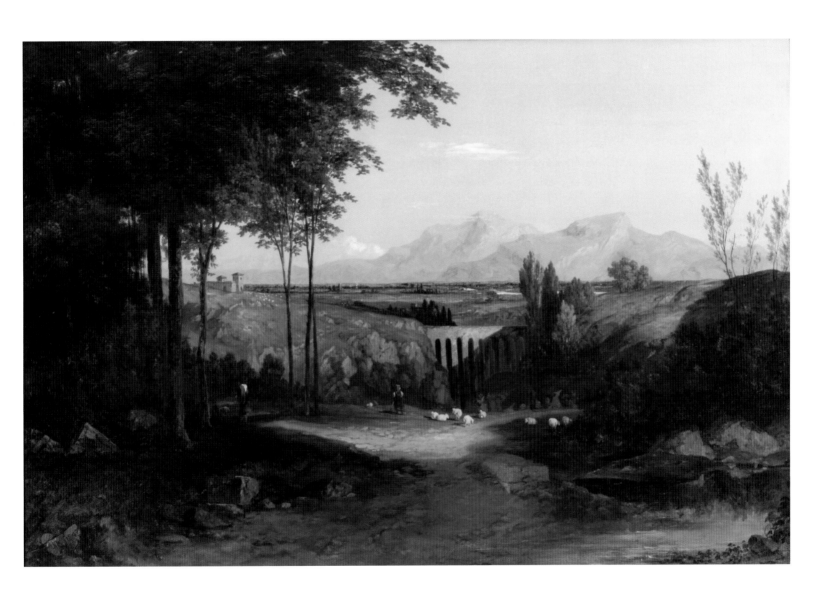

Sol LeWitt (1928–2007)
Tangled Bands (**Blue**)*,* 2005
Gouache on paper, 15 x 22 in.
Signed (lower right): *S. Lewitt '05; (verso): #014019*

Tangled Bands (**Red**)*,* 2005
Gouache on paper, 15 x 22 in.
Signed (lower right): *S. Lewitt '05; (verso): #014017*

Marla Prather
Senior Consultant
Nineteenth-Century, Modern, and
Contemporary Art
The Metropolitan Museum of Art
New York, New York

In many ways the gouache paintings on paper that LeWitt began to make in the early 1990s brought a remarkable career full circle. After all, he was the artist who, in 1968, ingeniously applied his drawing media directly to the wall, ultimately conceiving work he did not execute and designing them for limited duration and maximum flexibility in a vast array of architectural settings. Like the wall drawings, each gouache is unique, but each is independent work with fixed dimensions and permanent status, derived solely from the artist's expertly skilled hand.

While this pair of drawings may seem a far cry from the conceptual underpinnings and clear-eyed objectivity of LeWitt's early serial-based work, as he concluded in his seminal statement "Paragraphs on Conceptual Art" in 1967: "These ideas are the result of my work as an artist and are subject to change as my experience changes." Throughout LeWitt's career, the appearance of a new medium, in both his two- and three-dimensional work, opened up new compositional possibilities. And, as he moved over the years from graphite, to colored pencil, to ink wash, and to acrylic, the wall drawings took on startlingly complex and often powerfully illusionistic configurations.

For working on paper, gouache offered a more opaque medium than the ink washes LeWitt was using at the time on the wall. The curving, meandering red lines in each of these examples evolved naturally from the wavy brushstrokes and "loopy doopy" forms of the wall drawings that preceded them, but LeWitt deployed gouache's opacity to advantage here by partially obscuring the underlayers of color with parallel, wavy black lines. Ever since he made works such as *Floor Structure* (*Well*) (*Yellow*) or *Wall Structure in Nine Parts, Each Containing a Work by Other Artists*, both of 1963, with their mysterious, barely discernible interior forms, or buried a cube containing an undisclosed object in an undisclosed place in 1968, LeWitt revealed his penchant for concealment, unseen realms, and sequestered imagery. To find the *Tangled Bands* in these two drawings, we must peer beyond the blackness into the drawing's undulating, watery depths.

SELECT BIBLIOGRAPHY
Cross, Susan, and Denise Markonish, eds. *Sol LeWitt: 100 Views.* North Adams: MASS MoCA with Yale University Press, 2009.

Garrels, Gary, et al. *Sol LeWitt: A Retrospective.* San Francisco: San Francisco Museum of Modern Art, 2000.

Singer, Susanna, et al. *Sol LeWitt Drawings, 1958–1992.* The Hague: Haags Gemeentemuseum, 1992.

Singer, Susanna, ed. *Sol LeWitt Wall Drawings, 1984–1992.* Bern: Kunsthalle Bern, 1992.

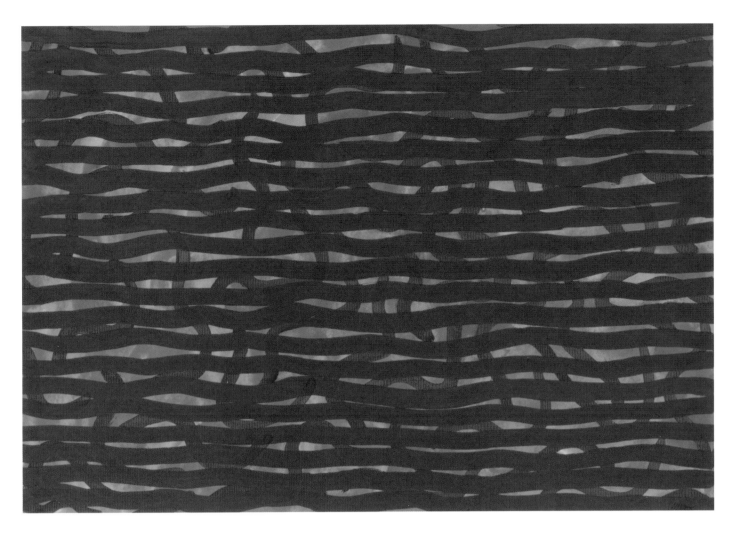

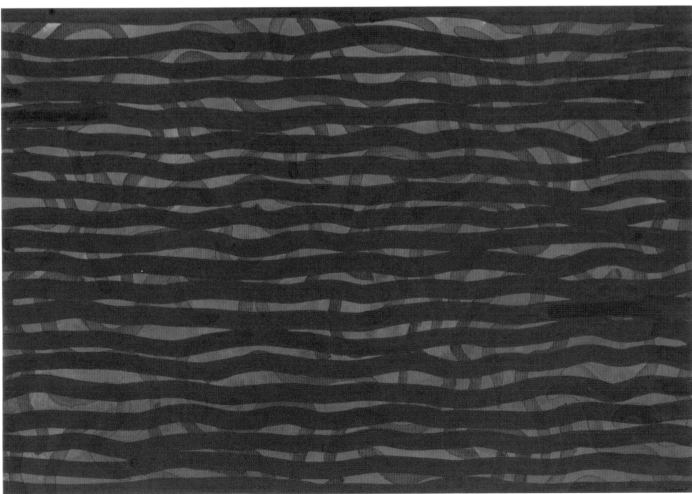

Lawrence Mazzanovich (1872–1959)
Autumn Afternoon, ca. 1915–20
Oil on canvas, 15 x 18 in.
Signed (center right): *Mazzanovich*

Alexander J. Noelle
Assistant Curator
New Britain Museum of American Art

William H. Gerdts, an expert on American Impressionism, claimed that Lawrence Mazzanovich was "one of the country's finest Post-Impressionists yet still awaits thorough study and presentation."[1] Mazzanovich was an outstanding and innovative artist who won acclaim both here and abroad. Upon arriving at the Westport, Connecticut, art colony, he quickly gained national attention with landscape paintings that placed him among the leading artists of his generation.[2]

Born at sea off the coast of California, Mazzanovich spent his childhood moving from city to city while his widower father searched for employment. As a youth, he worked in a silk factory in New Jersey, stripped tobacco in Baltimore, bartended and sold tobacco in New Orleans, and finally became apprenticed to a sign maker in Chicago—all before he turned sixteen.[3] After attending night classes in illustration at the School of the Art Institute of Chicago, he was hired in 1898 to work on illustrations for a limited edition of Oliver Goldsmith's *The Deserted Village.*[4] Shortly after marrying, Mazzanovich and his spouse, Ann, traveled to Europe in 1903. He studied landscape painting in France and Italy, which enabled him to abandon illustration, and exhibited work in the Barbizon style at competitions and at Paris Salons with great success. Just before returning to the United States, Mazzanovich began experimenting with Tonalism and Impressionism. At the request of a friend, he and Ann moved to the blossoming art colony in Westport in 1909.[5]

Down the coast from the thriving Old Lyme and Cos Cob art colonies, commercial illustrators such as Edward A. Ashe, George F. Wright, and John Held had established the Westport art colony between 1899 and 1907.[6] Unlike those at Old Lyme and Cos Cob, the Westport artists represented a mix of themes, styles, and even mediums. This small group of painters, sculptors, illustrators, and printmakers created an atmosphere of artistic exploration and freedom that attracted the noted modernist Arthur Dove, who spent ten years there developing his abstract style. The environment inspired Mazzanovich to experiment further, and his technique developed from Impressionism into a Pointillist, color-driven Post-Impressionist style.[7] While Karl Anderson, fresh from France and studies with Frederick Frieseke, may have been Westport's best figurative artist, Mazzanovich quickly became its finest landscape painter.[8]

Westport's quiet landscape was rich and varied, including abandoned barns, neighborhoods more than two hundred years old, streams, slopes, forests, and the Long Island Sound. It was the Saugatuck River, however, that prevailed as the main source of artistic inspiration. *Autumn Afternoon* explores the meandering river as well as varying effects of light and atmosphere. Related to his earlier *Poems of the Saugatuck,* the canvas shows Mazzanovich turning away from strictly Tonalist subject matter.[9] He retained the lively surface and rich color palette that garnered him fame yet employed a conventional composition with shadows and modeling not present in earlier works.[10] The new sense of decorative patterning, organization of forms, and brilliant colors links the work to Post-Impressionist and decorative Impressionist tendencies also explored by Childe Hassam, Daniel Garber, and Emil Carlsen.[11] *Autumn Afternoon* is a perfect example of Mazzanovich's broken brushwork combined with a tendency toward symmetry, which resulted in unnatural yet representational landscapes.[12] The "subjects of themselves are of slight importance to Mazzanovich. What he works for is effects of light and right, poetic impressions, tender and dream-like color harmonies."[13]

SELECT BIBLIOGRAPHY

Gerdts, William H. *American Impressionism.* New York: Cross River Press, 1984.

Gerdts, William H. *Art Across America: Two Centuries of Regional Painting, 1710–1920. Vol. 1: New England, New York, Mid-Atlantic.* New York: Cross River Press, 1990.

Lansing, Amy Kurtz, and Amanda C. Burdan. *Lyme in Mind: The Clement C. Moore Collection.* Old Lyme, Conn.: Florence Griswold Museum, 2009.

Price, Charles. *Painters of Light and Color: American Impressionists from the Lyman Allyn Art Museum and Private Collections.* New London: Lyman Allyn Art Museum, 1990.

Notes

1. Gerdts, *Art Across America*, p. 131.
2. Charles Teaze Clark, "Lawrence Mazzanovich in Connecticut," *Antiques* 170. no. 5 (November 2006): 148–55.
3. Ibid., p. 150.
4. Mazzanovich and illustrator William Wallace Denslow moved to upstate New York to be closer to the publisher, Roycroft Press. Denslow's wife, Ann, left him for Mazzanovich shortly after they arrived there. In 1923 Mazzanovich left her and moved to Tryon, N.C., where he met and married his second wife; see Clark, "Lawrence Mazzanovich," pp. 150–51, 154.
5. Mazzanovich moved to Westport with John

Adams Thayer, a publisher with whom he had worked and formed a friendship; see ibid., p. 151.
6. Gerdts, *Art Across America*, p. 129.
7. Lansing, *Lyme in Mind*, p. 40.
8. Gerdts, *Art Across America*, p. 129.
9. *Autumn Afternoon* is related to a series of five paintings entitled *Poems of the Saugatuck* shown at the Thurber Gallery, Chicago, in 1914; see Clark, "Lawrence Mazzanovich," p. 154.
10. Ibid.
11. Gerdts, *American Impressionism*, p. 188; and Price, *Painters of Light and Color*, p. 23.
12. Gerdts, *Art Across America*, pp. 130–31.
13. Clark, "Lawrence Mazzanovich," p. 151.

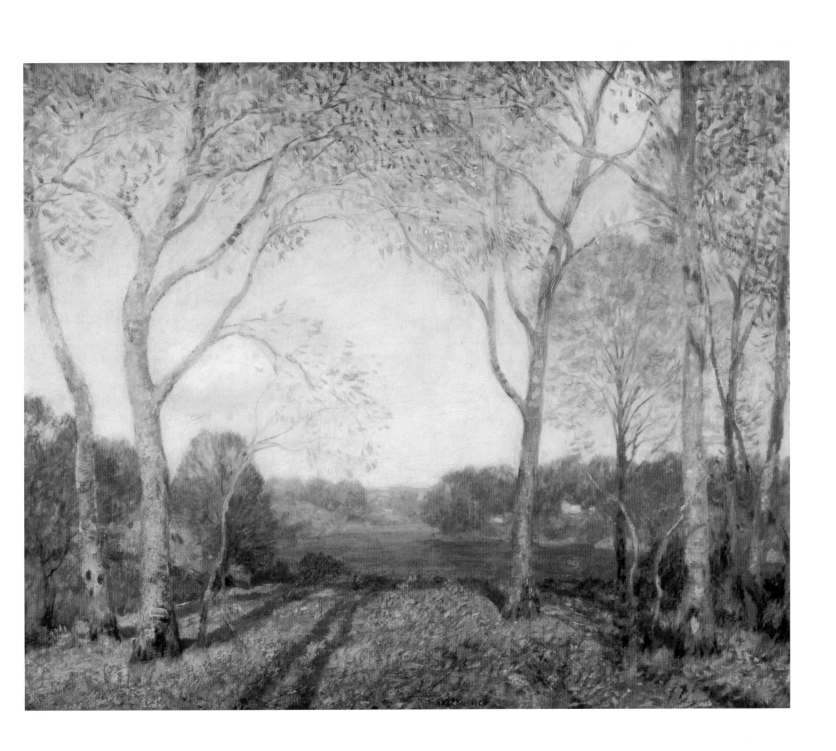

Graydon Parrish (b. 1970)
Rose, 2009
Oil on panel, 16 x 12 in.
Signed (lower left): *Graydon*

Douglas Hyland first introduced me to Graydon Parrish in 2002 at the New Britain Museum of American Art. I was familiar with his work from having seen his spectacular allegorical painting *Remorse, Despondence and the Acceptance of an Early Death* painted for the trustees of Amherst College in 1999. The pathos and realism captured in that canvas were so deeply affecting that I became convinced that Parrish would be an ideal choice for a museum commission to commemorate the tragic terrorist attack on New York in 2001. Douglas Hyland proposed the Museum commission a large mural to commemorate the 9/11 tragedy and the Museum's Art's Acquisition and Loan Committee were of like mind. Parrish accepted the commission to complete an eighteen-foot-long allegorical painting with eleven lifesize figures, which he titled *The Cycle of Terror and Tragedy: September 11, 2001* and completed in 2006. This great work succeeded beyond our expectations.

One of the many details of the work that struck me as particularly beautiful was the inclusion of dozens of roses on the ground at the feet of the painted figures, recalling

Dr. Timothy McLaughlin
Collector
Orthopedic Surgeon
Farmington, Connecticut

the many roses placed in front of New York fire stations in the days just after 9/11. These roses were reminders of the fragile but beautiful transience of life and struck a hopeful note that honored the memory of those who lost their lives on that fateful day.

I asked Parrish for a smaller, personal commission that would remind me of his magnum opus. A similarly sized rose painted by Martin Johnson Heade owned by the Museum helped me suggest the idea that Parrish interpreted and transformed into *Rose*. In my opinion, Parrish surpassed the achievements of the nineteenth-century academy with twenty-first century relevance. I believe he is one of the most talented young painters working in America today.

I love the calm, polished surface of Parrish's evocative work. He is a modern classicist endowed with great technical skill. I think my little memento, which is enshrined in a Troy Stafford tabernacle frame, captures forever a glimpse of the grace of Parrish's genius. His vision is both contemporary and timeless.

SELECT BIBLIOGRAPHY
Hedberg, Gregory. *The Eloquent Line: Master Drawings by Christopher Gallego, Nancy Lawton, Graydon Parrish.* New York: Hirschl & Adler Modern, 2002.

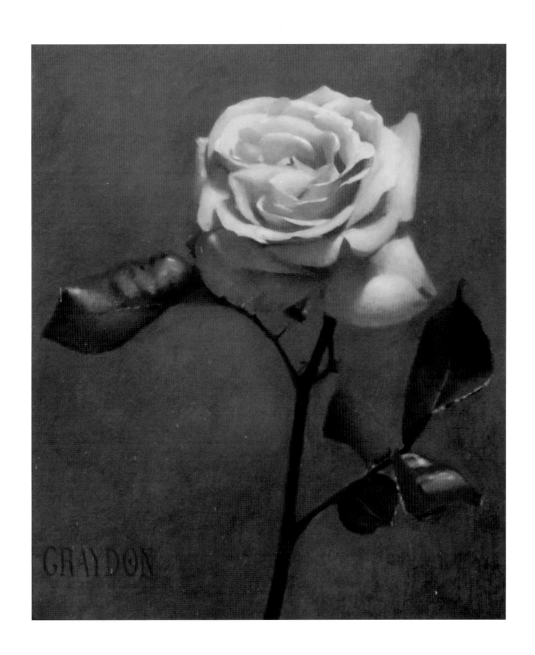

William McGregor Paxton (1869–1941)
Reclining Nude
Pencil on paper, 7½ x 9¾ in.
Signed (lower right): *Paxton*

Aden Weisel
Curatorial Intern
New Britain Museum of American Art

Beginning in 1887, William McGregor Paxton supplemented his high school education with evening classes at the Cowles School of Art in Boston under the tutelage of Dennis Miller Bunker (1861–1890),[1] a member of the "Boston School" of artists who had studied in Paris and returned to Boston.[2] Paxton, too, would become associated with this group. In 1889 he went to Paris to study under Bunker's former teacher Jean-Léon Gérôme (1824–1904) at the École de Beaux-Arts.[3] Although he is often associated with American Impressionism, Paxton experimented only briefly with the style, adhering to the academic manner that he learned in Paris for his entire career.[4]

Perhaps Paxton's most innovative work was in furthering the development of "binocularity." The "theory of binocular vision" was "first proposed by the critic W. O. Brownell in *French Art* in 1892, [and] . . . referred to the optical phenomenon that in seeing with both eyes the primary object of attention appears in focus, and all other areas are out of focus."[5] In paintings in this manner, the object of attention—most often a female figure in Paxton's work—is crisply modeled, while the background is rendered in looser, less finessed brushstrokes.

Upon his return to Boston in 1893, Paxton once again attended the Cowles School, where he befriended the instructor Joseph DeCamp (1858–1923), whose paintings of women in interiors influenced Paxton to adopt the subject. Paxton's images depict the wealth and materialism of Bostonian women at the turn of the century[6] and recall the paintings of Johannes Vermeer (1632–1675), earning Paxton the sobriquet the "American Vermeer."[7] The Dutch master's soft chiaroscuro lighting, realistic rendering of surface textures, and subject matter—young women reading, writing, and performing chores—are reflected in the work of his "namesake."

Another profound influence on Paxton was Jean-August-Dominique Ingres (1780–1867). Paxton's Parisian teacher Gérôme had been a pupil of Ingres, making Paxton an artistic descendant of Ingres. He recalled: "I spent endless days when I was a kid in Paris in the Louvre copying Ingres drawings. I think Ingres came nearer than any man who ever lived in achieving what he set out to do."[8] Long after he left France, Paxton executed an exact copy of Ingres's *Odalisque with a Slave* (1839–40; Fogg Museum, Harvard Art Museums) while it hung in the Philadelphia home of a friend in 1932.[9] Although not a copy, *Reclining Nude* is illustrative of Ingres's lasting influence on Paxton. Much like the nudes in Ingres's *Odalisque with a Slave* and *A Sleeping Odalisque* (ca. 1830; Victoria and Albert Museum, London), Paxton's model is fleshy and lies slightly propped up on a pile of cushions. All three women are posed with their knees bent toward the viewer, but their torsos turn away so that the axis of their shoulders nears the horizontal. Paxton's nude, like those of Ingres, verges on being a pinup, but modesty made both artists stop short of showing overtly erotic details. Paxton's work goes beyond a simple life drawing and verges on becoming an homage to a favored artist, one to whom he owed his artistic heritage.

SELECT BIBLIOGRAPHY
Baekeland, Frederick. *Images of America: The Painter's Eye, 1833–1925*. Birmingham, Ala.: Birmingham Museum of Art, 1991.

Baigell, Matthew. *Dictionary of American Art*. New York: Harper & Row, 1982.

Gerdts, William H. *American Impressionism*. New York: Abbeville Press, 1984.

Lee, Ellen Wardwell. *William McGregor Paxton*. Indianapolis: Indianapolis Museum of Art, 1979.

Notes
1. Lee, *William McGregor Paxton*, p. 26.
2. "Paintings by William Paxton, April 1–May 6, at Springfield, Mass. Museum of Art." Unidentified newspaper clipping, New Britain Museum of American Art, archives.
3. Lee, *William McGregor Paxton*, p. 28.
4. Baekeland, *Images of America*, p. 112.
5. Lee, *William McGregor Paxton*, p. 111.
6. Gerdts, *American Impressionism*, p. 212.
7. Baekeland, *Images of America*, p. 112

8. Ibid.
9. The painting was hanging in the home of the Philadelphia artist Carroll Tyson (1877–1956); see Lee, *William McGregor Paxton*, p. 145.

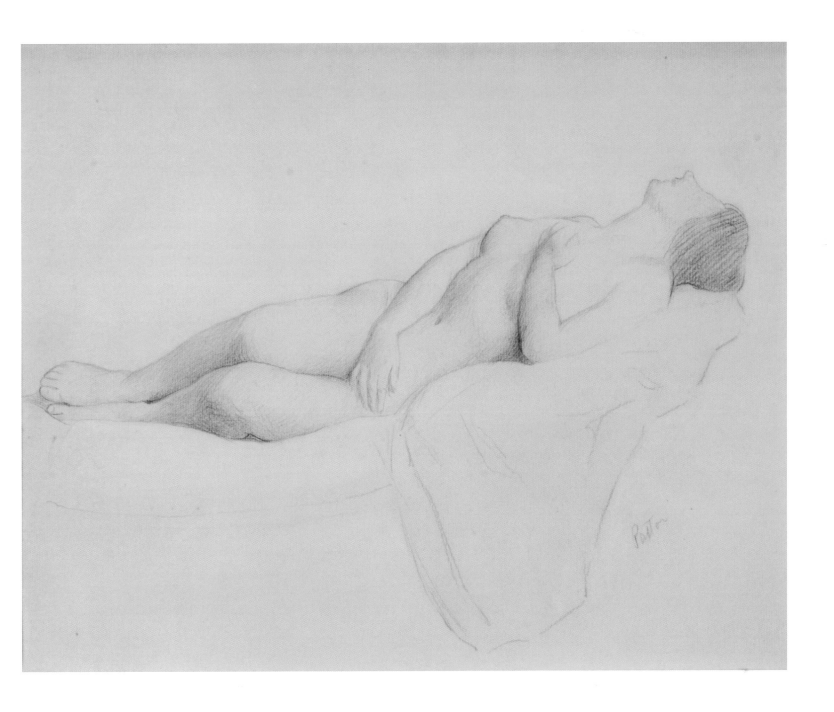

Rembrandt Peale (1778–1860)
George Washington, ca. 1824
Oil on canvas, 30 x 25 in.

Carole Jung
Curatorial Intern
New Britain Museum of American Art

Rembrandt Peale was born in Bucks County, Pennsylvania, into an incredibly talented family. His father, Charles Wilson Peale (1741–1827), one of the new country's most famous painters, was also a scientist and a museum director who had served as a close officer of arms to General Washington during the Revolutionary War. Charles was married three times and fathered seventeen children, eleven of whom survived. He named all his sons after renowned artists and scientists; three of them—Rembrandt, Titian, and Raphaelle—became famous artists themselves.

Rembrandt showed artistic talent early on, completing a self-portrait at the age of thirteen. He studied painting with his father and other artists in Philadelphia and attended classes in the chemistry of pigments at the University of Pennsylvania's new medical school. Peale subsequently lived and worked in New York and Boston and made five trips to Europe, where he briefly attended the Royal Academy in London (1802–3). He executed portraits of artists, writers, and scientists for his father's portrait collection when he was in Paris in 1808 and again in 1809–10. From 1828 until 1830, during his third European trip, he went to Italy, where he copied works by the Old Masters for collectors back home. From 1832 to 1833 Peale returned to England for what would be his final stay abroad. As a consequence of these sojourns, his painting style changed, revealing the influence of Jacques-Louis David (1748–1825), the French Neoclassical painter who was Napoleon's favorite artist. Peale was a founding member of the Pennsylvania Academy of the Fine Arts and of the National Academy of Design.

In 1795 George Washington posed for the seventeen-year-old Peale—it was the last portrait (Historical Society of Pennsylvania, Philadelphia) of the president to be done from life. Apparently, Charles arranged for and attended the sessions. Ever after his sittings with Washington, Peale sought to capture an ideal image of the first president. In 1799, after Washington's death, the president's family and friends felt that none of his portraits showed an appropriate semblance or evoked his dignified, thoughtful, yet energetic demeanor. Hence, Peale decided to try once again to capture Washington on canvas. Throughout the 1840s and 1850s he produced more than seventy pictures of the president. Some show him on horseback, others behind a stonework oval, and others wearing various uniforms. Peale even gave lectures on his replicas entitled "Washington and His Portraits," which he first delivered at the Historical Society of Pennsylvania. During these talks, he exhibited several of his copies, which were placed on easels and illuminated by gaslight.

This version of Washington is a replica of a portrait type established by Gilbert Stuart (1755–1828). After examining the Museum's canvas at the conservation laboratory of the National Portrait Gallery in October 1995, Lillian Miller, editor of the Peale Family Papers, suggested that it is an unfinished work—a trial executed by Peale sometime after 1824. In it Peale concentrated on the eyes and nose and was less concerned with the remaining features, as seen in the sketchlike representation of the jabot and suit and "the liney quality around the nose and eyes [as well as] the heavier pencilling around the lower hairline."[1] Thus, the painting provides the viewer with an opportunity to see Peale's working method and explore the manner in which the artist approached his subject.

SELECT BIBLIOGRAPHY
Elam, Charles H., et al. *The Peale Family: Three Generations of American Artists.* Detroit: Institute of Art, 1967.

Hevner, Carol Eaton. *Rembrandt Peale, 1778–1860: A Life in the Arts.* Philadelphia: Historical Society of Pennsylvania, 1985.

Miller, Lillian B. *In Pursuit of Fame: Rembrandt Peale, 1778–1860.* Washington, D.C.: National Portrait Gallery, 1992.

Peale Museum. *Rendezvous for Taste: Peale's Baltimore Museum, 1814 to 1830. An Exhibition Celebrating the 25th Anniversary of the Peale Museum, the Municipal Museum of the City of Baltimore, 1931–1956.* Baltimore: Peale Museum, 1956.

Note
1. Lillian B. Miller to Dr. Timothy P. McLaughlin, January 6, 1997.

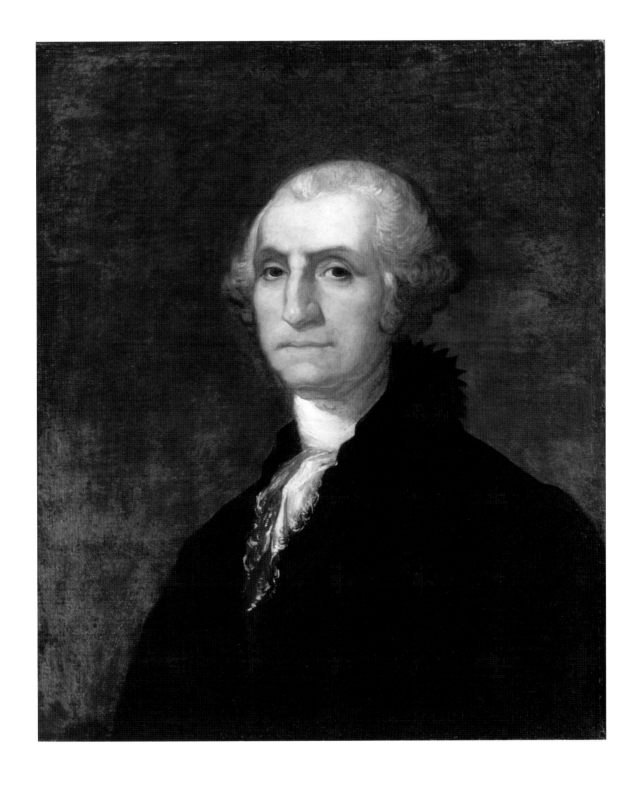

Henry Rankin Poore (1859–1940)
The Horse Pasture
Oil on panel, 10 x 18½ in.
Signed (lower right): *H. R. Poore*

Carole Jung
Curatorial Intern
New Britain Museum of American Art

Henry Rankin Poore was born in Newark, New Jersey, to a famous cleric. He spent his childhood in California and moved back to the East Coast in 1876. That year, Poore became interested in art after seeing a painting at the Centennial Exposition in Philadelphia. He began his art education by taking classes with Peter Moran (1841–1914) and subsequently enrolled at the Pennsylvania Academy of the Fine Arts in Philadelphia and then at the National Academy of Design in New York. In 1880 Poore attended the University of Pennsylvania, graduating in 1883. While at university, Poore was hired by the American government in 1882 to journey to the Southwest to illustrate the Pueblo Indians in New Mexico. He later traveled throughout Europe, studying in Paris with Évariste Vital Luminais (1821–1896) and William-Adolphe Bouguereau (1825–1905). During his second trip to Europe, in 1890, he discovered fox hunting, which became a lifelong interest and influenced many of his paintings and writings. Poore taught at his alma mater and also gave lectures and courses on composition at various institutions. He was also the author of several books and articles on art and art practices.[1] Throughout his life, Poore supported the use of pleasant colors and the formal rules of composition and was vocally opposed to modernism. He was, therefore, considered "one of the early twentieth century's foremost spokesmen for traditional values in the arts."[2]

The Horse Pasture is set in Old Lyme, Connecticut, site of the artists' colony founded by Henry Ward Ranger. The boardinghouse run by the arts patron Florence Griswold became the focal point of Old Lyme.[3] Poore was among the first artists to stay there; other prominent figures who visited included Childe Hassam and Willard Metcalf. Poore and Ranger left their stamp on the boardinghouse by painting the panels of its doors—a common custom at the country inns of the French art colonies of Barbizon, Pont-Aven, and Giverny, where artists would often lodge.[4]

Poore spent time at Old Lyme periodically from 1900 until about 1935, capturing nature firsthand. He was devoted to painting outdoors in every season and conceived a fully equipped, movable studio drawn by oxen to enable him to work in bad weather. *The Horse Pasture* shows the New England landscape and animals as well as figures for which Poore is known. The palette is restricted to green, brown, and yellow with pink in the lady's dress and the sky and dark blue in the vegetation in the background. The soft early morning light and haze create a peaceful, dreamlike feeling. The painting makes it easy to see why Poore and others were drawn to the beauty of Connecticut.

SELECT BIBLIOGRAPHY

Birmingham, Peter. *American Art in the Barbizon Mood.* Washington D.C.: Smithsonian Institution Press, 1975.

Gerdts, William H. *En Plein Air: The Art Colonies at East Hampton and Old Lyme, 1880–1930,* East Hampton: Guild Hall of East Hampton; and Lyme, Conn.: Lyme Historical Society, 1989.

Lyme Historical Society and Florence Griswold Museum. *Old Lyme: The American Barbizon.* Old Lyme, Conn.: Lyme Historical Society and Florence Griswold Museum, 1982.

Poore, Henry Rankin. *Pictorial Composition and the Critical Judgment of Pictures: A Handbook for Students and Lovers of Art.* Garden City, N.Y.: Doubleday, Page & Co., 1913.

Sellin, David, and Mark Sullivan. *Thomas Eakins and His Fellow Artists at the Philadelphia Sketch Club.* Philadelphia: Philadelphia Sketch Club, 2001.

Shipp, Steve. *American Art Colonies, 1850–1930: A Historical Guide to America's Original Art Colonies and Their Artists.* Westport: Greenwood Press, 1996.

Notes

1. His publications include *Pictorial Composition and the Critical Judgment of Pictures* (1903).
2. Lyme Historical Society and Florence Griswold Museum, *Old Lyme,* p. 43.
3. The house is now included on the grounds of the Florence Griswold Museum and has since been added to the National Register of Historic Places.
4. Florence Griswold Museum, "The Fox Chase," http://www.florencegriswoldmuseum. org/learning/foxchase/html/about_fox.php (accessed May 6, 2010).

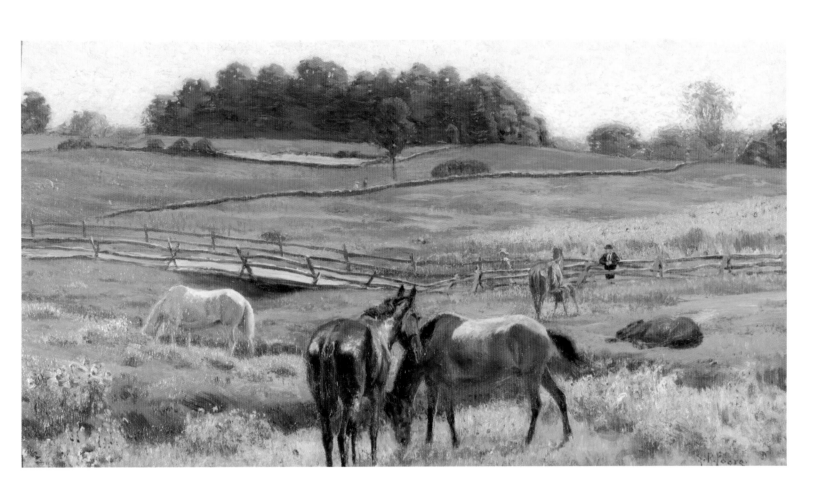

Henry Ward Ranger (1858–1916)
Interior of a Wood, 1913
Oil on panel, 12 x 16 in.
Signed (lower left): *H W Ranger 1913;*
(lower right) *Ranger NAD b 417*

Jillian Richard
Curatorial Intern
New Britain Museum of American Art

Henry Ward Ranger was born in Syracuse, New York, and studied art at Syracuse University. After completing his education he embarked for New York City in the hopes of becoming a successful watercolorist. It was in Manhattan that he first saw pictures by the Barbizon School, which exerted a powerful influence on him. In the early 1880s Ranger traveled abroad with his wife to study Barbizon paintings, which were renowned for their abandonment of formalism and for drawing inspiration directly from nature. The height of the French Barbizon masters had past, however, so Ranger became acquainted with a group of Dutch artists whom he felt were "the linear successors of the Barbizon school."[1] After a brief stay in Paris, Ranger and his family settled in Laren, Holland, where he worked closely with artists of the Hague School, such as Joseph Israels, Anton Mauve, and the Maris brothers. His paintings of quickly changing skies and diffused light earned him places in the Paris Salons of the late 1880s, and upon his return to the United States he became an accomplished follower of Barbizon traditions and a prominent landscape and marine painter.

The Europeanization of American art occurred between 1875 and 1914, as a vast number of American artists increasingly traveled to Europe to study. The emergence of the Barbizon school (1830–1870s) was linked to the political climate in France. Academic history painting was reduced to propaganda during the Napoleonic Empire and declined to a trivial level during the Bourbon Restoration, which resulted in a shift in subject matter from didactic subjects to the private contemplation of nature.[2] Literature of the time attempted to convey the natural beauty of the landscape as well. The critic John Ruskin advised artists to pay close attention to the details of nature in order to portray its essence and regarded art, nature, and morality as being unified spiritually. In his book *Modern Painters,* Ruskin criticized the Old Masters for their lack of attention to natural truths.

The emergence of the Barbizon School coincided with an increased interest in the desire to paint in the landscape itself, which was a prelude to Impressionism and modern art. European painters and writers alike, in the shift toward realism, exhibited their national pride by conveying the beauty of their country's landscape. Americans were introduced to Barbizon painting through William Morris Hunt, who had studied with the masters of the school firsthand and became the first American artist to work in the style.[3]

Ranger was a master of creating poetic woodland interiors. He merged European art with American subjects to create landscapes that convey a deep sense of history and a rural way of life. Pastoral vistas such as farm scenes and fields were vanishing at the time, as America changed from an agrarian to an industrial society.[4] The influence of the Barbizon School is evident in Ranger's loose brushstrokes, tonal palette, and poetic sentiment, as seen in *Interior of a Wood.* The canvas captures the splendor of a forest on an autumn day and invites the viewer into the painting through the use of perspective. The play of light and shadow within the lush vegetation creates a glow that fills the woods. The limited color scheme suggests that Ranger may have been influence by photography, yet his dabbed brushstrokes maintain a sense of movement and depth unachievable in a photograph.

SELECT BIBLIOGRAPHY
Lefebvre, Judith. *Connecticut Masters: The Fine Arts and Antiques Collections of the Hartford Steam Boiler Inspection and Insurance Company.* Hartford: Hartford Steam Boiler Inspection and Insurance Company, 1991.

Riback, Estelle. *Henry Ward Ranger, Modulator of Harmonious Color: A Monograph.* Fort Bragg, Calif.: Lost Coast, 2000.

Riback, Estelle. *The Intimate Landscape: A New Look at the Origins of the American Barbizon Movement.* Fort Bragg, Calif.: Lost Coast, 2004.

Rosenfeld, Daniel, and Workman, Robert G. *The Spirit of the Barbizon: France and America.* Providence: Museum of Art, Rhode Island School of Design, 1986.

Notes
1. Lefebvre, *Connecticut Masters,* p. 134.
2. Rosenfeld, *Spirit of the Barbizon,* p. 11.
3. Hunt studied in France under Jean-François Millet and upon his return to America set up a studio in Boston.
4. "Henry Ward Ranger and the Humanized Landscape," Florence Griswold Museum, http://www.tfaoi.com/newsm1/n1m240.htm (accessed April 20, 2010).

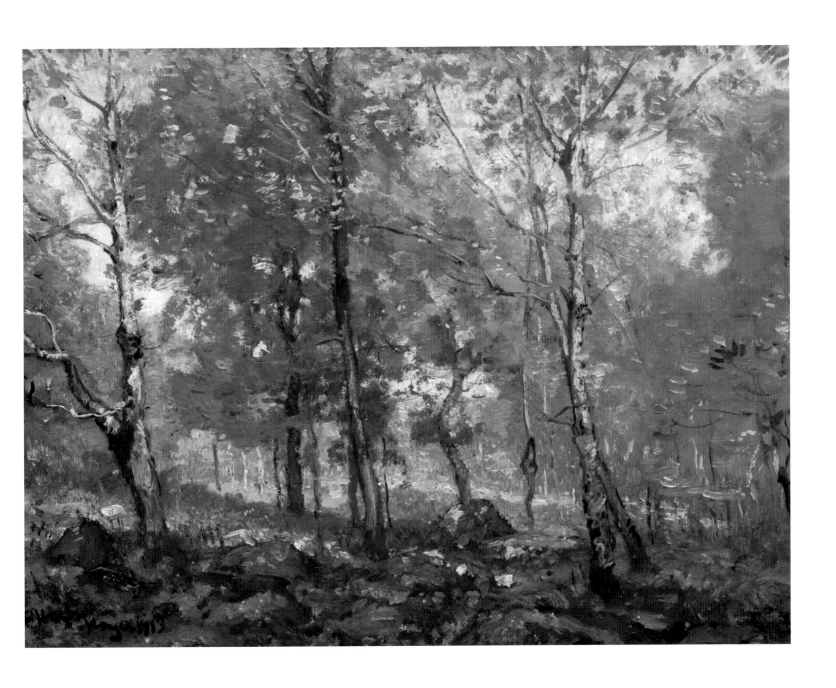

Henry Ward Ranger (1858–1916)
A Ledge of Rock, 1914
Oil on panel, 12 x 16 in.
Signed (lower left): *H W Ranger 1914*

Jeffrey W. Andersen
Director
Florence Griswold Museum
Old Lyme, Connecticut

The American Tonalist Henry Ward Ranger was the founder of the art colony at Old Lyme, Connecticut. After initially visiting the town in 1899, he returned in 1900 in the company of several artist friends. Arriving by train, he remarked: "It looks like Barbizon, the land of Millet. See the gnarled oaks, the low rolling country. This land has been farmed and cultivated by men, and then allowed to revert back into the arms of mother nature. It is only waiting to be painted."[1] Ranger saw Old Lyme as an American version of the French village of Barbizon and the Forest of Fontainebleau, where, earlier in the nineteenth century, artists had begun painting rural subject matter in muted color harmonies. Early in his career, Ranger had spent years absorbing this style in France and in Holland, where he especially admired the painters of the Hague School. Having long dreamed of gathering a group of colleagues to establish an art colony, the Connecticut shore was everything Ranger was seeking.

Lodging themselves at the boardinghouse of Miss Florence Griswold, Ranger and his circle spent days sketching and painting views of Old Lyme's meandering streams, meadows, and woods, which were noteworthy for their rock outcroppings and impressive variety of trees. *A Ledge of Rock* captures the region's distinctive geological features in which gigantic boulders and a rock ledge are interspersed with deep chasms and abundant tree growth. Ranger presents an intimate glimpse of nature, gained through direct experience with his subject. Although Ranger's larger exhibition oils were painted in the studio, smaller oil panels such as this one were frequently begun outdoors. It has many of the features typical of Ranger's work: expressive brushwork, carefully modulated colors, and a jewel-like paint surface, emphasized by translucent glazes that infuse it with feeling and character. Ranger believed that an artist's highest achievement was the "power to pass on an emotion."[2]

Ranger's leadership of the Lyme Art Colony ended soon after the arrival, in 1903, of the leading American Impressionist Childe Hassam, who influenced the colony's shift toward that style. By 1904 Ranger had departed for nearby Noank, a fishing village with a working harbor on the Mystic River. His impact at Old Lyme lingered, however, as many of the artists there incorporated aspects of Ranger's tonal approach in their plein air landscapes of the region.

SELECT BIBLIOGRAPHY
Andersen, Jeffrey W. *Old Lyme: The American Barbizon.* Old Lyme, Conn.: Florence Griswold Museum, 1982.

Becker, Jack. *Henry Ward Ranger and the Humanized Landscape.* Old Lyme, Conn.: Florence Griswold Museum, 1999.

Husted Bell, Ralcy. *Art-Talks with Ranger.* New York: G. P. Putnam's Sons, 1914.

Notes
1. Quoted in Lillian Baynes Griffin, "With the Old Lyme Art Colony," *New Haven Morning Journal and Courier,* July 5, 1907.
2. Quoted in Bell, *Art-Talks,* p. 170.

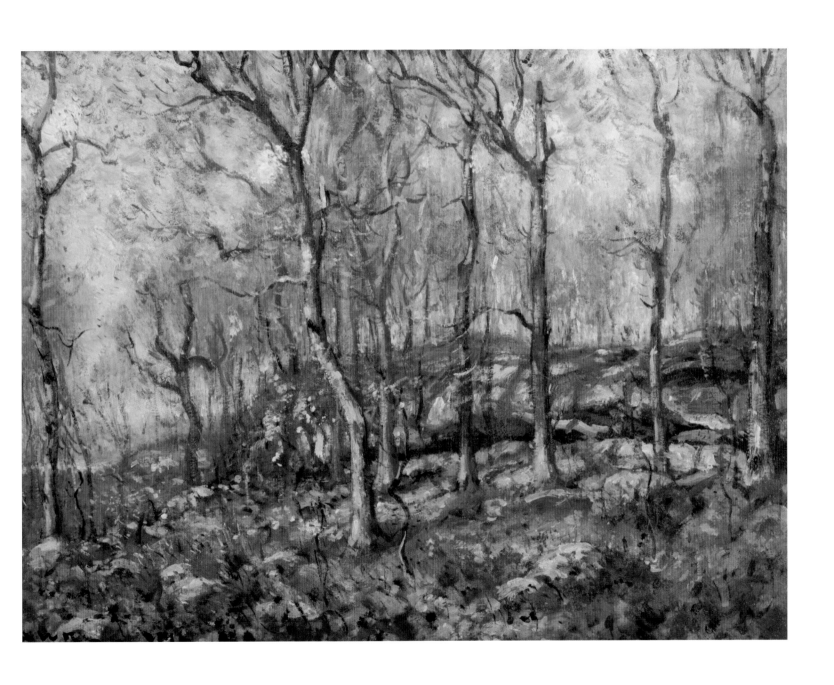

Aaron Draper Shattuck (1832–1928)
Landscape, Sunset over the Hills
Oil on artist's board, 12½ x 18¼ in.
Signed (lower left): *A. D. Shattuck*

Charles B. Ferguson
Director Emeritus
New Britain Museum of American Art

Several years after I became director of the New Britain Museum of American Art, in 1965, I received a telephone call: "Mr. Ferguson, my grandfather Aaron Draper Shattuck was a painter, and I have some of his 'sketches.' Will you come and see them?" So, I visited Mrs. Eugene Emigh, and what a treasure trove she had! Because her grandfather's painting career had ended nearly one hundred years before, his children and grandchildren hardly knew of his reputation as an artist. He had been elected a member of the National Academy of Design and had enjoyed a very successful career as a painter but had faded into complete obscurity by the early twentieth century. The serendipitous telephone call eventually led me to publish a reexamination of this important American artist in 1970.

Shattuck was born in New Hampshire. He first attended local schools and in 1851 studied portrait and landscape painting in Boston under the artist Alexander Ransom. In 1852 he moved to New York and took life classes at the National Academy. The year 1854 really marked the beginning of his landscape-painting career. He spent that summer in New Hampshire living next door to Asher B. Durand, who had taken the mantle of leadership of the Hudson River School of American landscape painting upon the death of Thomas Cole. Shattuck seemed to have absorbed Durand's landscape painting theories, published in the mid-1850s. Among Shattuck's artist friends were Frederic Church, Frederick Kensett, Samuel Coleman, and Sanford Gifford. In 1856 he began to sell—thirty-five paintings in Boston, with prices up to $100. Shattuck's career was launched. From a humble beginning with only $167, as he wrote in his diary, Shattuck

was able to earn an excellent living as an artist and amassed a sizable fortune. His painting career was, however, fairly short, between thirty and forty years, almost all of which were spent in New England. His later years were passed farming in Granby, where he invented a "stretcher key" and a tobacco-barn ventilating system. He was a man of many talents but had to stop painting due to poor health in 1888. When he died at age ninety-seven, he was the oldest member of the National Academy of Design.

There is no question that Shattuck studied and held Church's work in high esteem. Shattuck's *Sunset at Lancaster, New Hampshire* (1859; Frances Lehman Loeb Art Center, Vassar College) is closely related to Church's famous *Twilight in the Wilderness* (1860; Cleveland Museum of Art). The present work likewise captures the quiet of early evening and the most magnificent crepuscular atmospheric effects. The silhouetted, darkish land mass creates an optimum contrast to the brilliant yellows of the sky. There is also a subtle design in the pinkish clouds. The clouds at the upper left angle toward the center, while the ones to the right drift toward where the sun has just set.

The shadowed land, at first glance empty, has life: a farmhouse with a tiny window light, a flock of sheep, and, to the right, gentle ripples on the water that mirror the sky. With this small painting, Shattuck tried and succeeded in capturing the majestic hush and peace of twilight. Shattuck embodies the true spirit of the Hudson River School and has finally taken his place among the greats of nineteenth-century American painting.

SELECT BIBLIOGRAPHY
Ferguson, Charles B. *Aaron Draper Shattuck, N.A., 1832–1928: A Retrospective Exhibition.* New Britain: New Britain Museum of American Art, 1970.

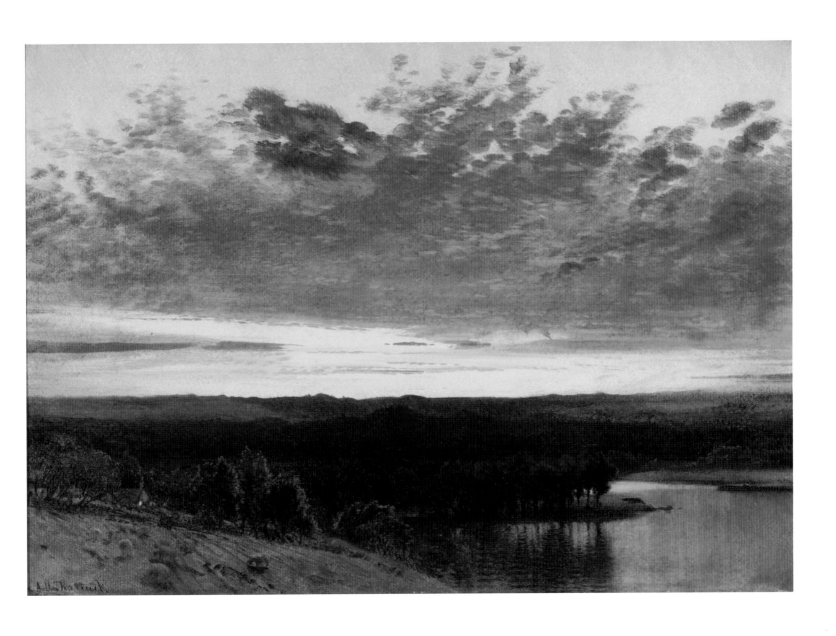

John Sloan (1871–1951)
Connoisseurs of Prints, from the series
New York City Life, 1905
Etching, 4 $^{15}/_{16}$ x 7 in.
Signed (lower right): *John Sloan*

Elizabeth Kennedy
Curator of Collection
Terra Foundation for American Art
Chicago, Illinois

Handsome, idealistic, acerbic, long-lived, and a true believer in Robert Henri's philosophy of the individualism of artistic expression, John Sloan was one of the most reliable narrators of an artist's struggle to remain true to his artistic vision. Sloan lived and worked in Philadelphia until 1903, when he joined his former newspaper illustrator colleagues William Glackens, George Luks, and Everett Shinn in New York. The older Henri, who had taught Sloan at the Pennsylvania Academy of the Fine Arts, was also there to inspire his young protégé. Thoughtfully and with commitment, Sloan developed a persona that was recognized as the apogee of an independent artist who would never allow patronage—private or commercial—to compromise the integrity of his art.

Sloan thought not only about art but also about the audience for art. In *Connoisseurs of Prints,* the first etching in his series *New York City Life*, begun in 1905, he devoted his efforts to representing people looking, critiquing, and becoming befuddled by prints hanging at an exhibition. The satirical narrative reveals his alert eye and witty juxtapositions of viewers. Apparently based on actual observation of an exhibition of prints to be auctioned at the American Art Galleries, Sloan had intended this etching to be one of a series on the subject of connoisseurs.[1]

Connoisseurs of Prints represents women and men pressing their faces close to the small works of art on paper. The artist deliberately contrasts the act of individual looking and appraisal by posing the male visitor in the light suit and magnifying glass with an adjacent female art lover, both silently scrutinizing individual works. In contrast is the critical commentary of two older male viewers nearby, whose carefully delineated facial expressions are meant to represent acquired knowledge of art through their collective experience, who appear to be making their opinions loudly heard. Amusingly, at the left stands a wealthy potential patron, distinguished by her ermine boa, clutching an auction catalogue close to her face. It is hard to determine if her distressed expression reflects a greedy anticipation of the forthcoming sale or signifies her horror at the estimated prices.

There is no doubt that Sloan was condescending in his evaluation of the credentials of this audience to be the rightful judges of the quality of the artworks for sale. Throughout his career, Sloan was a master narrator of the world of the artist as a superior observer of life.

SELECT BIBLIOGRAPHY

Leeds, Valerie Ann. *The World of John Sloan.* Orlando, Fla.: Mennello Museum of American Art, 2009.

Loughery, John. *John Sloan: Painter and Rebel.* New York: Henry Holt and Company, 1995.

Morse, Peter. *John Sloan's Prints: A Catalog Raisonné of the Etchings, Lithographs, and Posters.* New Haven: Yale University Press, 1969.

St. John, Bruce, ed. *John Sloan's New York Scene, from the Diaries, Notes and Correspondence, 1906–1913.* New York: Harper & Row, 1965.

Vure, Sarah. "Art Matters: John Sloan, Independence, and the Aesthetic Consumer." In Elizabeth Kennedy, ed. *The Eight and American Modernisms.* Chicago: University of Chicago Press, 2009, pp. 145–53.

Note
1. Morse, *John Sloan's Prints*, p. 135.

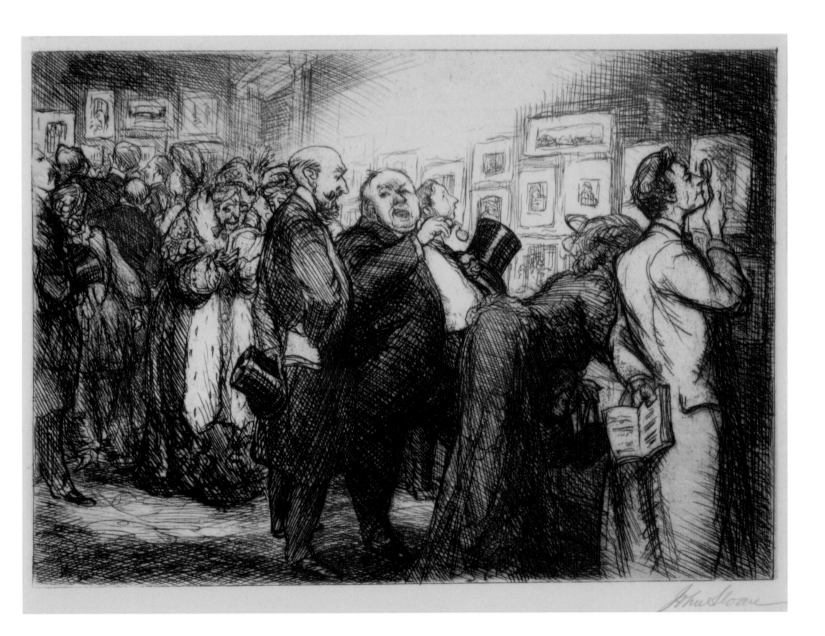

John Sloan

John Sloan (1871–1951)
The Picture Buyer, 1911
Etching, 5¼ x 7 in.
Signed (lower right): *John Sloan*

John Sloan and his wife, Dolly, thrived in the questionable neighborhoods of lower Manhattan, where the artist closely observed—and, of equal importance—considered the implications of the daily lives of fellow New Yorkers. Imaginatively, he merged the visual and narrative messages in the cultures surrounding him. Far too many critics have called him a realist who etched and painted vignettes of ordinary life without applauding his selection and alteration to fit his vision of the critical moment. In art and in life, Sloan was an artist and a teacher who taught aesthetic technique while encouraging the selectivity of an individual's eye, whether artist or art lover.

Sloan's leadership in realizing the independent exhibition of friends collectively known as The Eight at Macbeth Gallery in 1908 gave him critical insights into the commercial art world, as his own sales were notoriously few. In the etching *The Picture Buyer,* Sloan, the satirical observer, once again sneeringly parodied the practices of art patronage, revealing his scathing opinion of the art market. In his notebook, he described the actual scene as a "pretty comedy," with art dealer William Macbeth showing paintings to a prospective buyer as other visitors to the gallery tiptoed in awe around him.[1]

Elizabeth Kennedy
Curator of Collection
Terra Foundation for American Art
Chicago, Illinois

A few months later, when the American art collector John Quinn purchased the print, Sloan wrote to him, "An incident in the galleries of William Macbeth—he is shown purring in the ear of the victim."[2] Obviously, the artist and the modern art collector were scornful of the hierarchy of the art market and those on the fringes of knowledge—whether they were rich consumers of prestigious goods or the middling classes aspiring to ascend to a higher cultural realm.

In 1913 Sloan submitted *The Picture Buyer* to the infamous Armory Show, where current and future collectors could laugh at others or, perhaps, themselves as they contemplated the overwhelming choices of contemporary works. Sloan's derisive if humorous response to the control of others in validating his art through their purchases spurred his leadership in founding the Society of Independent Artists; he was elected president of this organization of avant-garde artists in 1916. That year he also joined the faculty of the Art Students League, where he would nurture several generations of important modernist artists while instilling in them his legacy of artistic integrity.

SELECT BIBLIOGRAPHY

Leeds, Valerie Ann. *The World of John Sloan.* Orlando, Fla.: Mennello Museum of American Art, 2009.

Loughery, John. *John Sloan: Painter and Rebel.* New York: Henry Holt and Company, 1995.

Morse, Peter. *John Sloan's Prints: A Catalog Raisonné of the Etchings, Lithographs, and Posters.* New Haven: Yale University Press, 1969.

St. John, Bruce, ed. *John Sloan's New York Scene, from the Diaries, Notes and Correspondence, 1906–1913.* New York: Harper & Row, 1965.

Vure, Sarah. "Art Matters: John Sloan, Independence, and the Aesthetic Consumer." In Elizabeth Kennedy, ed. *The Eight and American Modernisms.* Chicago: University of Chicago Press, 2009, pp. 145–53.

Notes

1. Morse, *John Sloan's Prints,* p. 177.
2. Ibid.

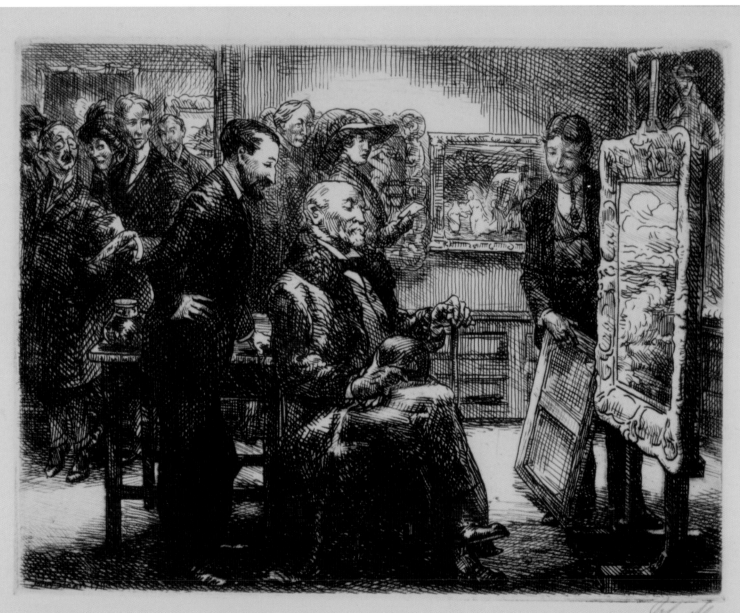

The Picture Buyer John Sloan

Edward Gregory Smith (1880–1961)
By the Edge of the Lieutenant River,
Old Lyme, CT, 1915
Oil on canvas, 30 x 38 in.
Signed (lower right): *Gregory Smith*

Christy Johnson
Curatorial Intern
New Britain Museum of American Art

In 1910 Edward Gregory Smith moved from Grand Rapids, Michigan, to a small town off the shore of the Long Island Sound known for its affiliation with the arts: Old Lyme, Connecticut. Florence Griswold (1850–1937), a local woman from a long line of politicians, lawyers, and salesmen, first opened her home there to boarding artists in 1899, creating the Lyme Art Colony along with the Tonalist artist Henry Ward Ranger.[1] Smith joined the colony at the request of his friend Will Howe Foote. The colony had become a prestigious gathering of American Impressionists when Childe Hassam arrived in 1903. Smith was highly influenced by Hassam's work as well as that of Willard Metcalf. Foote, who had gone to Old Lyme in 1901, shifted his Tonalist style to Impressionism after Hassam converted the colony.

Smith began staying in Old Lyme year-round in 1916, when he and his wife, Annie, built a house and a studio there. In 1925 a fire destroyed the studio and most of Smith's paintings.[2] During winters, Smith remained in Connecticut while Annie took the children to Florida. He was president of the Lyme Art Association, organized in 1914, for more then twenty years. Smith received several awards at the Lyme Art Association, including the W. S. Eaton Purchase

Prize in 1922, the Mr. and Mrs. William O. Goodwin Prize in 1931 and 1936, and the Woodhull Adams Memorial Prize in 1927.

The Griswold House overlooks the Lieutenant River, which connects with the Connecticut River. The house opened as the Florence Griswold Museum in 1947 and is now known as "the home of American Impressionism." In 1993 it was proclaimed a National Historic Landmark. Also now overlooking the Lieutenant River, the Robert and Nancy Krieble Gallery was opened by the museum in 2002.[3]

The Lieutenant River was a popular subject for the artists of Old Lyme. Smith's canvas depicts a beautifully rendered tree arcing gracefully over the river. The pastel colors of the autumn leaves on the other shore are reflected in the water, appearing both liquid and solid. A small blue boat peeps out behind a rock in front of the tree. The high key of the light green grass contrasts with the dark leaves of the tree rendered in broken brushstrokes. Smith's painting shows the beauty of Old Lyme through its colorful depiction of the lush natural surroundings of the Griswold House.

SELECT BIBLIOGRAPHY

Gerdts, William H. *Art Across America: Two Centuries of Regional Painting: 1710–1920. Volume 1: New England, New York, Mid-Atlantic.* New York: Cross River Press, 1990.

Lefebvre, Judith. *Connecticut Masters: The Fine Arts and Antiques Collections of the Hartford Steam Boiler Inspection and Insurance Company.* Hartford: Hartford Steam Boiler Inspection and Insurance Company, 1991.

Rovetti, Paul F. *Connecticut and American Impressionism: A Cooperative Exhibition Project Concurrently in Three Locations.* Storrs, Conn.: William Benton Museum of Art, 1980.

Smith, Edward Gregory. *Notes on the Florence Griswold House by Gregory Smith.* Old Lyme, Conn.: Lyme Art Colony Papers, Lyme Historical Society Archives [ca. 1950].

Notes

1. Rovetti, *Connecticut*, p. 117.
2. Ibid, p. 173.
3. Florence Griswold Museum: Museum Timeline, http://www.flogris.org/thestory/timeline.html (accessed May 12, 2010).

Peter Waite (b. 1950)
Hill-Stead, 2010
Acrylic on aluminum panel, 26 x 20 in.
Signed (verso): *Peter Waite 2010*

Peter Waite has become one of the finest painters of contemporary landscapes and cityscapes, architectural interiors, and public monuments. His paintings range from panoramic views of winter in New England to the claustrophobia of a deserted indoor swimming pool filled with toxic-looking water. He is equally at home and confident painting in Paris or Berlin as he is in East Hartford or Middletown. Over the past twenty years, he has created a personal landscape, a recognizable and consistent view of the world—"Waite-land," one might call it.

There are many components to it. Chief among them is the careful, thoughtful selection of the motif, be it a bridge over the Connecticut River or Frederick the Great's summer palace in Berlin, Sans Souci. He chooses each motif because it evokes a mood or reveals a hidden, historic significance. The bridge at Middletown, its steel girders rearing above your head, carries the full whack and weight of the stifling humidity of a Connecticut August. Sans Souci becomes, in Waite's view, the epitome of "vanished supremacies," the husk and hulk of history. Waite's realism is always the world transformed, not just transcribed. He creates contemporary versions of the *paysage moralisé*—the landscape moralized, a place infused with purpose and meaning. The artist prompts us to think about the picture by dragging his brush against the image or letting the paint drip and run, reminding us that we are looking at a painting, a work of art, and not just a "scene" or a "view." What is it saying? What does it imply?

SELECT BIBLIOGRAPHY
Mahoney, Robert. "Peter Waite." *Time Out,*
New York (July 1996).

Smith, Roberta. "Peter Waite at the Edward
Thorp Gallery." *New York Times,* July 5, 1996.

Patrick McCaughey
Former Director
Wadsworth Atheneum Museum of Art
and Yale Center for British Art

The beautiful and accomplished *Hill-Stead* (the artist likes the hiccup in the title) shares these qualities. Waite takes one of the most persistent and evocative motifs of modern art—the play of the cool, shaded interior set against the brilliantly lit exterior. The viewer is securely placed inside the gazebo, with its meticulously rendered brick floor and intricately constructed wooden roof. Texture and tactility are among the painting's most winning qualities. The wooden benches on either side are invitations to the viewer to pause. The lattice woodwork on either side of the doorway likewise acts as a brake against the onrush of light and heat beyond the gazebo. The command of the painting is clear: the viewer is pressed or challenged to walk through the shaded interior along the low hedgerows to the picturesque sundial. But the exterior world is all glare, an onslaught on the senses, after the reassuring brick-and-wood-constructed coolness of the gazebo. This otherwise lyrical subject takes on a disconcerting quality: we are moved, imaginatively, from the safe and the contained to the blinding light of summer.

T. S. Eliot's *Four Quartets* opens with a similar disconcerting evocation and invitation:

> *Footfalls echo in the memory*
> *Down the passage we did not take*
> *Towards the door we never opened*
> *Into the rose garden . . .*
>
> *Other echoes*
> *Inhabit the garden. Shall we follow?*

John Ferguson Weir (1841–1926)
East Rock, New Haven
Oil on canvas, 25 x 30 in.
Signed (lower right): *John F. Weir*

Marian Wardle
Curator of American Art
Brigham Young University Museum of Art
Provo, Utah

John Ferguson Weir belonged to a family of important American artists. His father, Robert W. Weir, was Professor of Drawing at the United States Military Academy at West Point for forty-two years. John received his art instruction from his father, who also taught, among others, his son the American Impressionist Julian Alden Weir and James Abbott McNeill Whistler. John quickly achieved artistic success with two large paintings of industrial themes and was elected to the National Academy at the age of thirty. He was the first director of the Yale School of Art (1869–1913), where he established the first academic art program at an American university.

In 1895 Weir wrote to his brother, "Mary and I walked up to the top of East Rock on Saturday, and it was simply marvelous—."[1] Five years later Weir painted his first known view of East Rock, a Connecticut landmark on the border of New Haven and Hamden. The Weirs were among the many visitors to the site, a prominent basalt ridge that rises some 350 feet above the Mill River. In 1880 the ridge and the surrounding area became East Rock Park and a road was built for easy access to the summit.[2] In *East Rock, New Haven* the ridge appears via the approach from New Haven, with the Mill River at its base. The loose brushstrokes, abundant foliage, and emphasis on light give the soft feel of Impressionism, a style often adopted by Weir in the 1890s and early 1900s.

Weir painted at least five views of East Rock.[3] He exhibited his earliest known version (ca. 1900; Florence Griswold Museum, Lyme, Conn.) at the National Academy in 1900. The picture, in autumnal hues, presents the ridge from the New Haven side, with no hint of the road to the summit, the nearness of the town, or the Soldiers' and Sailors' Monument (1887) at the crest.[4] Weir painted a similar, larger version in 1906 (Yale University Art Gallery, New Haven). Neither the road nor the monument appears in any of Weir's East Rock paintings, but the town emerges in one, *New Haven from East Rock* (ca. 1900–1901; New Haven Museum and Historical Society). *East Rock, New Haven* and *New Haven from East Rock* may be read as companion pieces, as both display copious greenery, loose brushwork, and an interest in light. In *New Haven from East Rock*, the ridge is on the left with a view to the southwest, the smokestacks of the town in the distance; *East Rock, New Haven* portrays the ridge on the right with a view to the northeast on the approach from New Haven.

Like his paintings of the Hudson River from his boyhood home at West Point and his renditions of Lake Como in Italy, Weir's views of East Rock seemingly denote his attachment to specific locations.[5] The natural landmarks may have given him a profound sense of place. In painting them, he made them his own.

SELECT BIBLIOGRAPHY
Fahlman, Betsy. *John Ferguson Weir: The Labor of Art.* American Art Series. Newark: University of Delaware Press; London: Associated University Presses, 1997.

John Ferguson Weir Papers. Manuscripts and Archives, Yale University Library, New Haven.

Wardle, Marian, et al. *The Weir Family, 1820–1920: Expanding the Traditions of American Art.* Forthcoming.

Notes
1. John F. Weir to Julian and Ella Weir, September 30, 1895, Weir Papers, folder no. 134, box no. 5, series no. 1, Mss. 550.
2. See *East Rock Park at New Haven, Conn.: Illustrated in Photo-Gravure* (New York: A. Wittemann, 1897), http://books.google.com/books (accessed March 8, 2010).
3. Not far from East Rock is West Rock, another picturesque ridge that was depicted by Frederic Edwin Church (1826–1900) in his famous *West Rock, New Haven* (1849; New Britain Museum of American Art).
4. On the monument, see *Official Program of Exercises Incident to the Dedication of the Soldiers' and Sailors' Monument at East Rock Park, New Haven, Conn., Friday, June 17th, 1887* (New Haven: John B. Judson, 1887), http://books.google.com/books (accessed March 6, 2010).
5. Weir's paintings of the Hudson and Lake Como include *View of the Highlands from West Point* (1862; New-York Historical Society) and *Lake Como* (1869; Yale University Art Gallery, New Haven).

James Abbott McNeill Whistler (1834–1903)
Billingsgate, 1859
Etching, $5\frac{7}{8}$ x $8\frac{7}{8}$ in.
Signed (bottom right): *Whistler. 1859*

Elizabeth Kennedy
Curator of Collection
Terra Foundation for American Art
Chicago, Illinois

The innovative works of art by the American expatriate James Abbott McNeill Whistler roiled the modern world art at the end of the nineteenth century. He stands alone in his influence on European, British, and American art, and his important contributions to modernism by an American artist are unparallel. Whistler's unconventional childhood, spent in Saint Petersburg and London, apparently left him ill prepared for success in the United States. Determined to become an artist, the brash young man left for Europe in 1855, never to return to his native land, though he always boasted of himself as an American. Whistler spent his long career shuttling between the art capitals of Paris and London.

Boldly experimental in painting, printmaking, pastel drawing, and interior design, Whistler broke ground not only in the modern nature of his themes but also in their aesthetic treatments. When he moved to London in 1858, already a gifted engraver, he embraced the "etching revival" program pioneered by his brother-in-law Seymour Haden. Whistler also brought from Paris the modernism of the French critic Charles Baudelaire, who called for depicting scenes of contemporary life.

In August 1859 Whistler rambled throughout London, especially the disreputable dockyards along the city's famous river, and created a suite of etchings, including *Billingsgate,* now known as *The Thames Set.* The artist himself pulled proofs only that year and the next. Eleven years later the plates were transferred to steel face, facilitating mass publication. Further editions were published in 1879 and 1890; all the plates were canceled in 1897.

Whistler's intent was to depict the working men whose livelihoods were intimately connected to the Thames as well as to show the river "as it was in 1859" by etching scenes that were "a little portrait of a place."[1] The fish market Billingsgate is the most western location of his Thames views, and a distant glimpse of London Bridge and the tower of Saint Saviour's Church (Southwark Cathedral) is visible behind the row of sailboats. (The scene was etched as the artist saw it; therefore, the actual topography is reversed in the print.)

The foreground barge, its structure lightly delineated, is cleverly juxtaposed against the densely inscribed ships, with their multiple tall masts and rigging, which weave a tangled web above the placid river. Whistler's optical magic invites both close inspection, as of details of the ancient watergate's towers at the left, as well as the compulsion to pull away to make sense of the various components of the densely packed riverscape. Among his greatest achievements, Whistler's etchings were revolutionary at their conception and critical to his reputation and lasting acclaim.

Select Bibliography
Curry, David Park, *James McNeill Whistler at the Freer Gallery of Art.* New York: W. W. Norton and Freer Gallery of Art, 1984.

Kennedy, Edward, ed. *The Etched Work of Whistler.* 2 vols. San Francisco: Alan Wotsy Fine Arts, 1978.

Lochman, Katherine. *The Etchings of James McNeill Whistler.* New Haven: Yale University, 1984.

Merrill, Linda, et al. *After Whistler: The Artist and His Influence on American Painting.* New Haven: Yale University Press, 2003.

Note
1. Kennedy, *Etched Work*, p. 82.

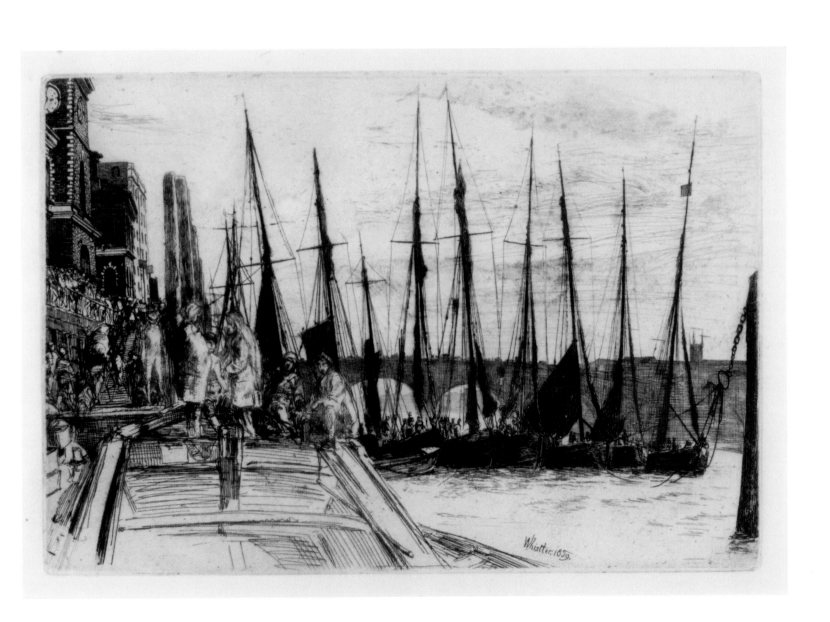

James Abbott McNeill Whistler (1834–1903)
La Robe Rouge, 1894
Lithograph, $7^3/_8$ x $6^1/_{16}$ in.
Signed (center left): butterfly cipher

Elizabeth Kennedy
Curator of Collection
Terra Foundation for American Art
Chicago, Illinois

James Abbott McNeill Whistler argued for a "pure" art independent of moral themes or even subject matter. His doctrine of "art for art's sake" laid the foundation for the so-called Aesthetic Movement in art and design, which glorified pure pattern and color in richly decorated objects.

Charming, combative, and convinced of his own genius, Whistler was a flamboyant and even outrageous personality, as provocative as his art. His relations with patrons, fellow artists, and critics were often contentious, as were his stormy affairs with his models. In contrast, the artist was respectful of his mother, whom he immortalized in his most famous painting, and of his wife, Beatrix, the widow of his architect friend E. W. Godwin. The surprisingly devoted and attentive husband frequently portrayed Trixy after their marriage in 1888, continuing until her untimely death in 1896.

Whistler's art and life were forever intertwined, as affectionately documented in a drawing of his wife resting on a sofa in their Left Bank Paris home at 110 rue du Bac. In a letter to Thomas Way, his London lithographic producer, Whistler described in detail two companion drawings, both created on the evening of September 22, 1894, that he sent to him for transfer into lithographs: *La Robe Rouge (The Red Dress)* and *La Belle Dame Endormie (Beautiful Woman Sleeping)*. These two drawings are the most precisely dated within Whistler's lithographic oeuvre. *La Robe Rouge* was one of the artist's favorite lithographs, which Way pulled in a large machine-printed edition for the publication *The Studio.*

Whistler was emphatic in describing to Way the specific visual effects he hope to achieve in these two drawings: "I rely on their simplicity for their success. . . . —we will call No. 1 'La Robe Rouge'—I rather want to see how the colour is conveyed!—'you' will think me quite crazy!—No. 2 'La Dormeuse.'"[1] Whistler's eccentric notion of entitling the portrait of his wife as the "red dress" is typical of his emphasis on non-narrative art, but his curiosity to see the "colour" affect of the black-and-white image—if he meant "red" and not a tonal sense of contrast—is odd.

The artist's title provides the only clue to the viewer that the dress, with its tight bodice and elaborate mutton sleeves, is red. Reclining on a sofa in their drawing room, Beatrix rests her head on a pillow and clasps her hands gracefully at her waist while gazing at her husband sketching her. It has been suggested that her weary pose reflects early symptoms of her fatal cancer. Throughout his career, however, Whistler had frequently sketched and painted his models and mistresses lounging on a sofa or a chaise lounge. The loving artist fixed his famous butterfly monogram, without its stinger, alongside the image of Trixy—ensuring that his affectionate presence would accompany his wife in this artwork. These moments of intimacy were inspired by Whistler's passion for drawing and for his muses; ironically, the narcissistic side of the artist delighted in revealing his private life to thousands of admirers through mediums such as lithographs and etchings.

SELECT BIBLIOGRAPHY
Curry, David Park, *James McNeill Whistler at the Freer Gallery of Art.* New York: W. W. Norton and Freer Gallery of Art, 1984.

Kennedy, Edward, ed. *The Etched Work of Whistler.* 2 vols. San Francisco: Alan Wotsy Fine Arts, 1978.

Lochman, Katherine. *The Etchings of James McNeill Whistler.* New Haven: Yale University Press, 1984.

Merrill, Linda, et al. *After Whistler: The Artist and his Influence on American Painting.* New Haven: Yale University Press, 2003

Note
1. Lochman, vol. 1, pp. 334–35.

Thomas Worthington Whittredge (1820–1910)
Catskill Mountains Twilight, ca. 1863–65
Oil on board, 4¾ x 7⁷⁄₁₆ in.

Blair Apgar
Curatorial Intern
New Britain Museum of American Art

Growing up in rural Ohio, Thomas Worthington Whittredge developed an intimate connection to nature. He sought, by his own admission, "simple things and simple subjects, or it may be that I never got into the way of measuring all grandeur in a perpendicular line."[1] Whittredge traveled throughout Europe from 1849 to 1859, studying with Emanuel Leutze at the Düsseldorf Academy, where he befriended the future Hudson River School painters Albert Bierstadt and Sanford Gifford. In 1859 Whittredge returned stateside, settling in New York City. He was elected a full member of the National Academy of Design in 1862 and served as president in 1874–75.[2]

In Whittredge's *Catskill Mountains Twilight,* both his aesthetic preferences and those of his Hudson River School peers, particularly Asher B. Durand, are evident.[3] The small size and intimate brushwork indicate that the sketch was done from nature, as does the absence of a signature.[4] The scene is of a valley at dusk, as the sun's rays barely peek over the mountains. The brushwork in the sky and the tree in the foreground are precisely rendered, which is rather astonishing considering the size of the canvas. The middle ground is more roughly painted, yet the colors observed in nature keep the view accurate and believable. Whittredge biographer Anthony Janson commented, "The sketch is one of the few from nature by Whittredge from these years that is so finished, making it a complete work of art in its own right. . . . [It is] the finest oil sketch from nature I know by his hand. Indeed,

it is a perfect gem of a painting, in some respects preferable to [others] because of its freshness and unity."[5]

After Whittredge's sojourn in Europe, Gifford helped him translate his experiences into American terms. The two would often travel together and paint side by side, producing many canvases that depict nearly identical vistas.[6] *Catskill Mountains Twilight* closely resembles Whittredge's late *View of Kaaterskill Falls* (1864–65; private collection), though there are some differences in details. Janson speculated about these variations: "The mountain masses have been adjusted to emphasize the breadth of the scene, the framing trees have been conspicuously omitted so as not to close off the view and suggest that it continues infinitely to the right, and the sky has become more tempestuous."[7] The two paintings, while based on nearly the same geographical feature, were completed at different times of day. While *Catskill Mountains Twilight* has a warm-toned horizon, there are strong blue tones in the background, reflecting the coming of night. Conversely, *View of Kaaterskill Falls* was painted earlier in the afternoon, most likely on a different day, though there is a hint of darkness reflected in the stormy sky.

In the tradition of the Hudson River School and the era of Romanticism, there is the smallest hint of human life or at least of civilization. The two spiraling wafts of smoke at the left reveal the presence of man, evoking the woodland home of the Native Americans who lived in the area at the time.[8]

SELECT BIBLIOGRAPHY
Avery, Kevin J. *Hudson River School Visions: The Landscapes of Sanford R. Gifford.* New York: Metropolitan Museum of Art, 2003.

Janson, Anthony F. *Worthington Whittredge.* Cambridge and New York: Cambridge University Press, 1989.

O'Toole, Judith. *Different Views in Hudson River School Painting.* New York: Columbia University Press, 2008.

Notes
1. Claudia E. James, "Worthington Whittredge: Drawings from Life," *American Art Journal* 25, no. 4 (1985).
2. William G. Keener, "The Education of a Painter: Thomas Worthington Whittredge," *Timeline* 12, no. 3 (1995): 34–49.
3. Janson, *Worthington Whittredge,* pp. 71–84.
4. Few of Whittredge's oil sketches done in situ bear his signature; see Anthony F. Janson to Jennifer Krieger, Gallery Director, Questroyal Fine Art, LLC, December 23, 2002.
5. Ibid.

6. The scene in *View of Kaaterskill Falls,* largely based on *Catskill Mountains Twilight,* is nearly identical to that in Sanford Robinson Gifford's *Kauterskill Clove* (1862; Metropolitan Museum of Art, New York).
7. Janson to Krieger.
8. Ibid.

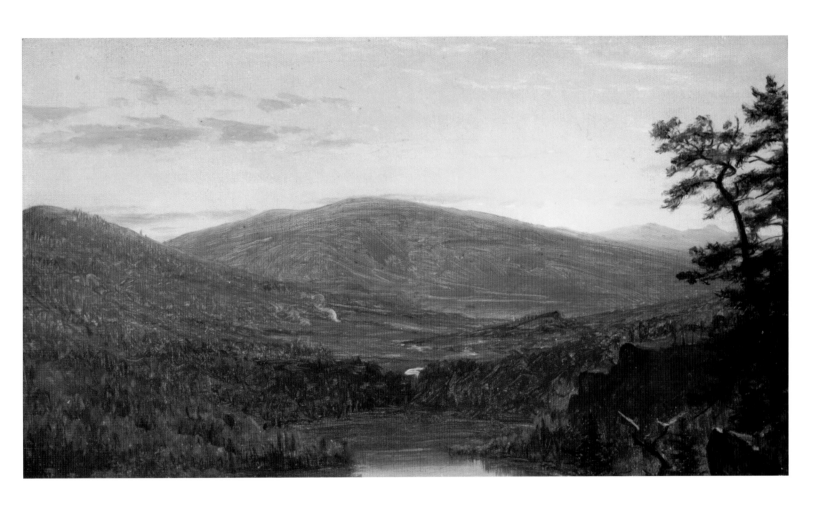

Guy C. Wiggins (1883–1962)
Times Square, 1931
Oil on board, 10 x 8 in.
Signed (lower left): *Guy Wiggins*

Carole Jung
Curatorial Intern
New Britain Museum of American Art

Born in Brooklyn, Guy Carlton Wiggins spent his youth in England, where he attended the Truro Grammar School. He traveled extensively throughout Europe with his parents, and, thanks to watercolors he painted in France and the Netherlands at the age of eight, he began to receive recognition in New York City newspapers.[1] Wiggins first studied painting with his father, Carleton Wiggins, adhering to the American landscape tradition.[2] About 1900, Wiggins attended the Polytechnic Institute in Brooklyn to study architecture and drawing but soon left and enrolled at the National Academy of Design. There, he studied first with William Merritt Chase and subsequently with Robert Henri. At the age of twenty, Wiggins became the youngest American artist to have a work in the permanent collection of the Metropolitan Museum of Art.

In 1920 Wiggins began spending summers at the Lyme Art Colony, where he became one of the younger members of the group of American Impressionists. The Old Lyme artists had created their own version of Impressionism "by fusing French technique with American conventions."[3] Wiggins was determined to hold onto his own style, which had its foundations in French Impressionism and was influenced by Childe Hassam as well as other members of The Ten. He continued to paint in this style long after it was considered outdated. In 1937 Wiggins moved to Essex and established the Guy Wiggins Art School, where he hosted famous artists such as George Luks, Eugene Higgins, and John Noble.

In the late 1920s Wiggins became well known for his scenes of New York City streets in winter, which he often painted from office windows. Wiggins choice of urban subject matter may have stemmed from his early study of architecture as well as the influence of Robert Henri and The Eight. While Wiggins's snow scenes usually included only a solitary figure,

Times Square shows a hustle-bustle of vehicles fighting their way through the snow in the busy traffic, surrounded by skyscrapers of the 1920s and 1930s. The palette is limited to various grays with yellow and red highlights from office windows, building façades, and cars.

Since his snowscapes embrace dense veils of snow, Wiggins was challenged with working with white; similarly, James Abbott McNeill Whistler and John H. Twachtman often tackled mainly white compositions. It appears that Wiggins did not pursue this challenge vigorously but instead chose "to constantly emphasize color, elevating it above all else and achieving luminosity through it."[4] Adrienne Walt suggests that Childe Hassam (1859–1935) had a significant impact on Wiggins, especially his later New York snow scenes that include flags.[5] In an interview in the Detroit News in 1924, Wiggins explained his feelings about his snow scenes:

> One cold, blustering, snowy winter day [1912] I was in my New York studio trying to paint a summer landscape. Things wouldn't go right, and I sat idly looking out of a window at nothing. Suddenly I saw what was before me—an elevated railroad track, with a train dashing madly through the whirling blizzard-like snow that made hazy and indistinct the row of buildings on the far side of the street [*Metropolitan Tower,* 1912; Metropolitan Museum of Art]. Well, when I gave an exhibition a short time afterward . . . the winter canvases were sold before anything else. In a week, so to say, I was established as a painter of city winter scenes, and I found it profitable. Then suddenly I felt a revulsion against them and I stopped. Everyone said I was a fool and was shutting the door upon opportunity, maybe fame. Just the same I couldn't go on with winter stuff and that was all there was to it.[6]

SELECT BIBLIOGRAPHY
Campanile Galleries. *Guy C. Wiggins: American Impressionist.* Chicago: Campanile Galleries, 1970.

Kienholz, Kathleen. *Artists of the Lyme Art Association: From Childe Hassam and William Robinson to Gershon Camassar.* Old Lyme, Conn.: Lyme Art Association, 1998.

Rovetti, Paul. *Connecticut and American Impressionism.* Storrs, Conn.: University of Connecticut, 1980.

Notes
1. Adrienne L. Walt, "Guy Wiggins: American Impressionist," *American Art Review* 4, no. 3 (1977): 110.
2. The famous Old Lyme landscape painter Carleton Wiggins (1848–1932) is best known for pictures of herds of sheep grazing on dark meadows underneath gloomy skies. Guy C. Wiggins's son, Guy A. Wiggins (b. 1920), became a full-time artist later in life, concentrating on still lifes, cityscapes, and landscapes.
3. Lawrence J. Cantor and Company, "Artist Biographies: Guy Carleton Wiggins," http://www.fineoldart.com/browse_by_essay.

html?essay=484 (accessed June 29, 2010).
4. Walt, "Guy Wiggins," p. 112.
5. Ibid.
6. Quoted in Rehs Galleries, Inc., "Guy C. Wiggins (1883–1962): The New York Scene," http://www.rehsgalleries.com/guy_c_wiggins_the_new_york_scene.html (accessed June 29, 2010).

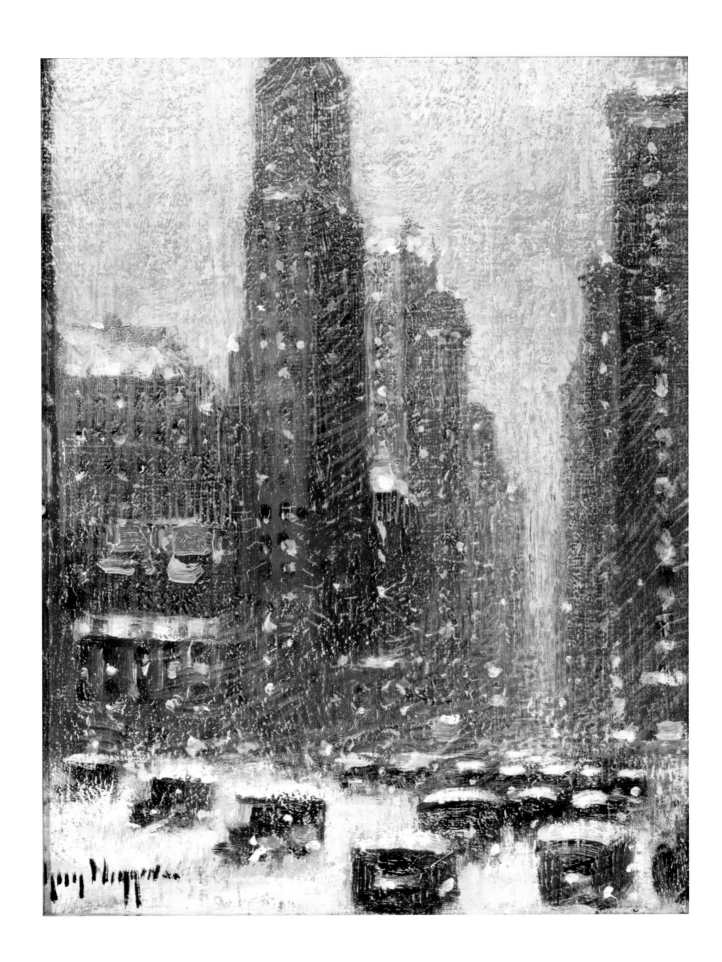

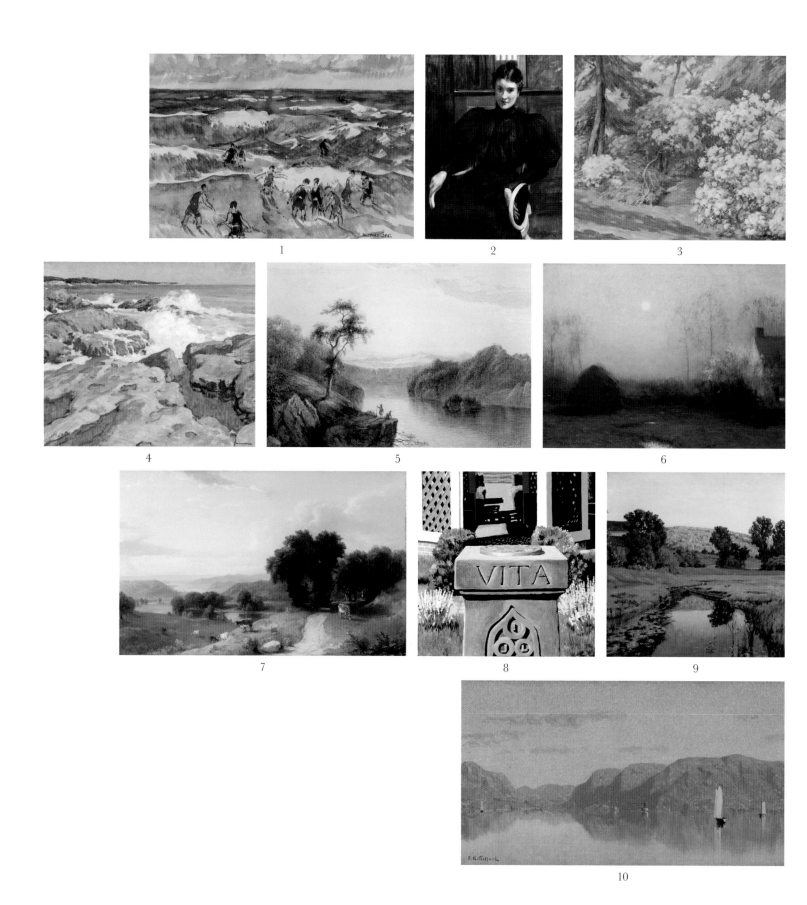

1. Gifford Beal (1879–1956). *Swimming in the Surf,* ca. 1925. Watercolor, 12 x 16 in.; 2. James Carroll Beckwith (1852–1917). *Portrait of a Lady (Study of Minnie Clark).* Oil on canvas, 22 x 18 in., see p. 17; 3. William Chadwick (1879–1962). *Laurel among the Pines.* Oil on canvas, 20 x 24 in.; 4. William Chadwick (1879–1962). *Millstone Point.* Oil on canvas, 24 x 30 in., see p. 19; 5. William C. Craig (1829–1875). *Native American View.* Watercolor on paper, 17 x 22 in.;

6. Bruce Crane (1857–1927). *May Moon,* 1907. Oil on canvas, 22 x 30 in., see p. 21; 7. Asher B. Durand (1796–1886). *Landscape with Cattle,* 1861. Oil on canvas, 10 x 16 in., see p. 23; 8. Terry Donsen Feder (b. 1945). *Vita.* Oil on aluminum, 18 x 18 in.; 9. Ben Foster (1852–1926). *The Meeting House.* Oil on canvas, 30 x 30 in., see p. 25; 10. Sanford Robinson Gifford (1823–1880). *Hudson River Highlands,* ca. 1867. Oil on canvas, mounted on board, 5½ x 10 in., see p. 27

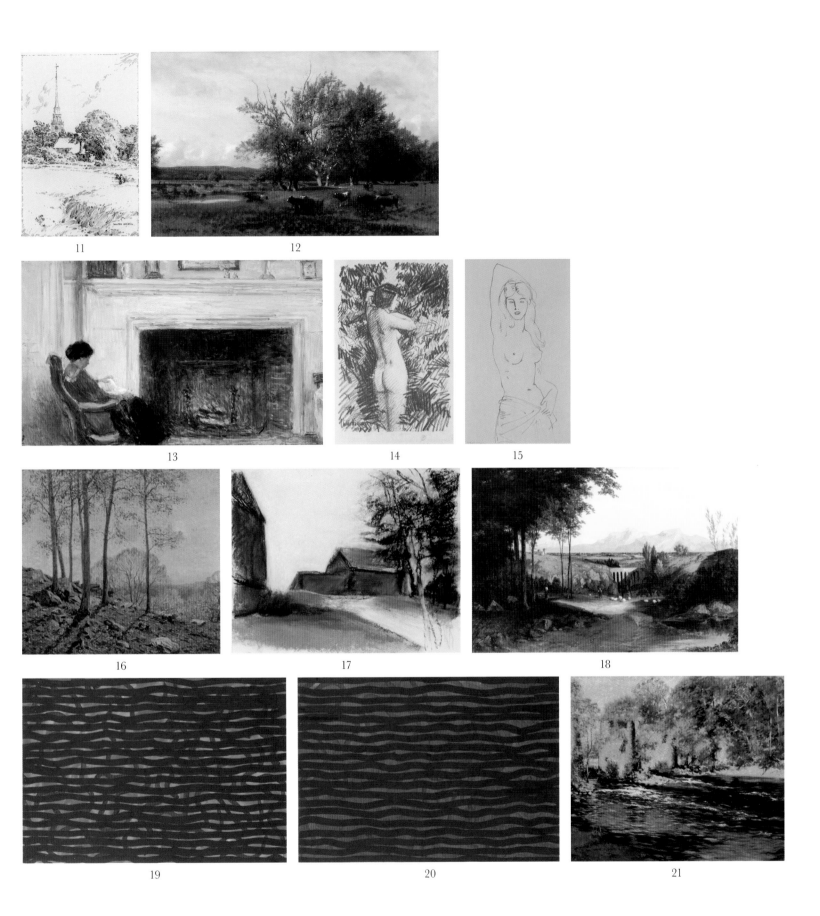

11. Walter Griffin (1861–1935). *Congregational Church*. India ink on paper, 10½ x 7 in.; 12. James McDougal Hart (1828–1901). *Farmington River.* Oil on canvas, 14 x 22 in., see p. 29; 13. Childe Hassam (1859–1935). *Fireplace in the Old House*, 1912. Oil on cigar box panel, 5½ x 9 in., see p. 31; 14. Childe Hassam (1859–1935). *Nude*, 1918. Lithograph on laid paper, 14¼ x 9½ in.; 15. Robert Henri (1865–1929). *Untitled (Nude with Arm over Head)*. Pen and ink on paper, 9 x 5½ in., see p. 33; 16. Wilson Henry Irvine (1869–1936). *Sunlight and Shadows*, 1917. Oil on canvas applied to board, 24 x 27 in., see p. 35; 17. Wolf Kahn (b. 1927). *Richard Hamilton Barns*, 2006. Pastel on paper, 11 x 14 in., see p. 37; 18. John Frederick Kensett (1816–1872). *A View in Italy,* 1847. Oil on canvas, 23⅞ x 35⅞ in., see p. 39; 19. Sol LeWitt (1928–2007). *Tangled Bands (Blue)*, 2005. Gouache on paper, 15 x 22 in., see p. 41; 20. Sol LeWitt (1928–2007). *Tangled Bands (Red)*, 2005. Gouache on paper, 15 x 22 in., see p. 41; 21. Robert H. Logan (1874–1942). *Ruins of the Aqueduct, Farmington, Connecticut*, 1916. Oil on canvas, 25 x 30 in.

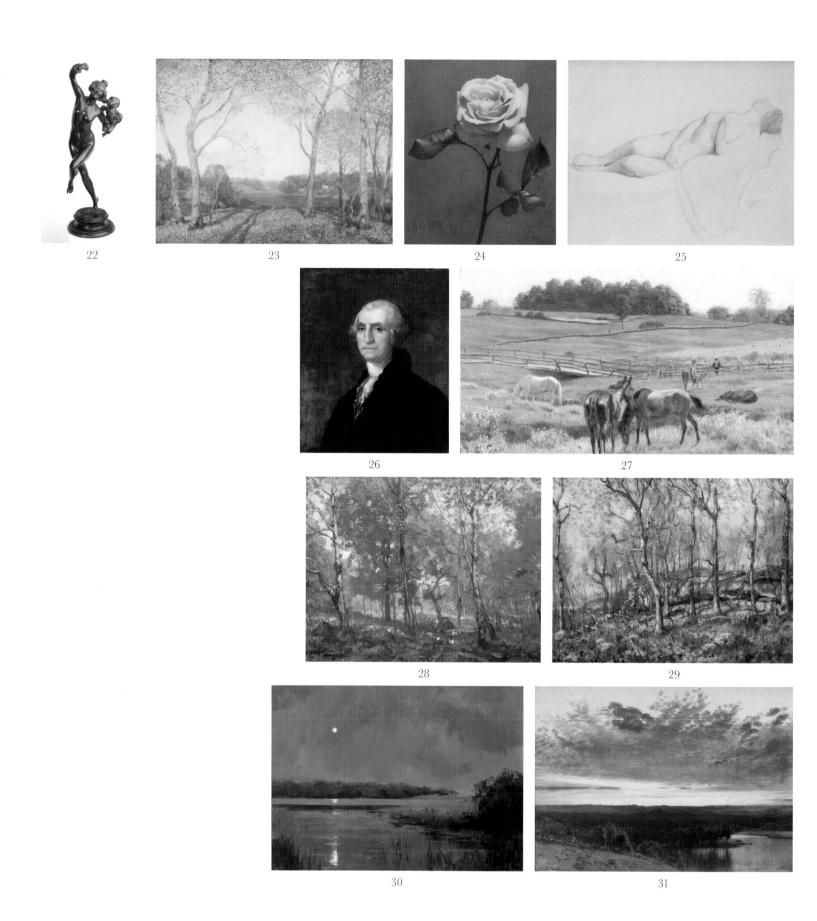

22

23

24

25

26

27

28

29

30

31

22. Frederick MacMonnies (1863–1937). *Bacchante and Infant Faun,* ca. 1894. Casting, 16 x 5 in.; 23. Lawrence Mazzanovich (1872–1959). *Autumn Afternoon,* ca. 1915–20. Oil on canvas, 15 x 18 in., see p. 43; 24. Graydon Parrish (b. 1970). *Rose,* 2009. Oil on panel, 16 x 12 in., see p. 45; 25. William McGregor Paxton (1869–1941). *Reclining Nude.* Pencil on paper, 7½ x 9¾ in., see p. 47; 26. Rembrandt Peale (1778–1860). *George Washington,* ca. 1824. Oil on canvas, 30 x 25 in., see p. 49; 27. Henry Rankin Poore (1859–1940). *The Horse Pasture.*

Oil on panel, 10 x 18½ in., see p. 51; 28. Henry Ward Ranger (1858–1916). *Interior of a Wood,* 1913. Oil on panel, 12 x 16 in., see p. 53; 29. Henry Ward Ranger (1858–1916). *A Ledge of Rock,* 1914. Oil on panel, 12 x 16 in., see p. 55; 30. Peggy N. Root (b. 1958). *Moonlight, Fishers Island,* 1990. Oil on canvas, 34 x 48 in.; 31. Aaron Draper Shattuck (1832–1928). *Landscape, Sunset over the Hills.* Oil on artist's board, 12½ x 18¼ in., see p. 57

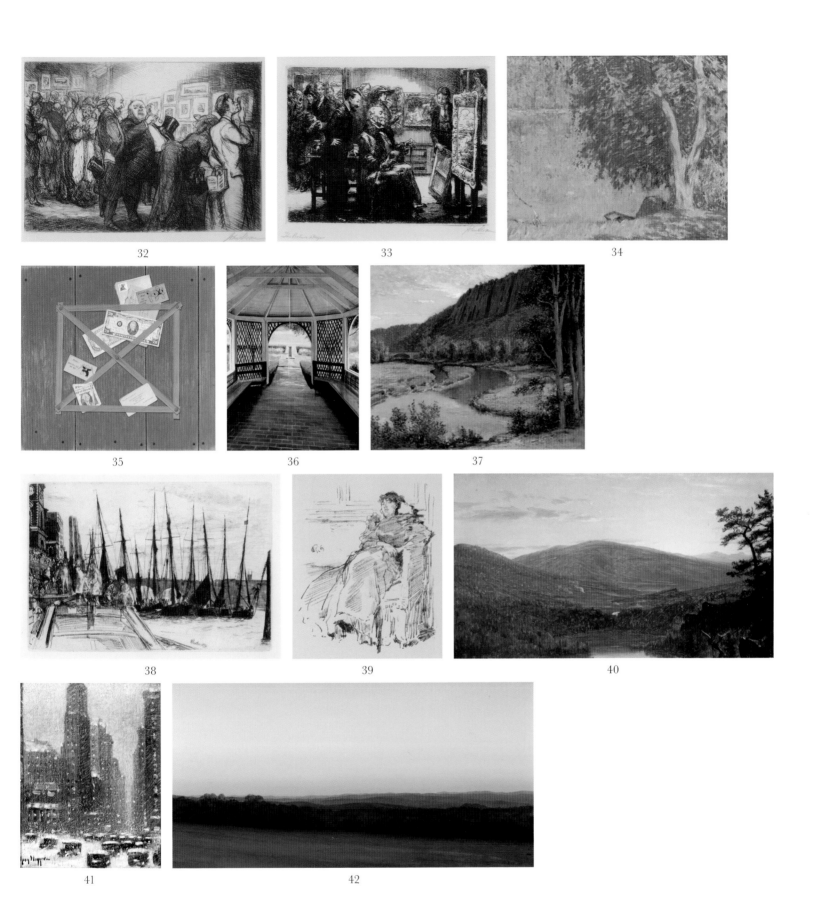

32

33

34

35

36

37

38

39

40

41

42

32. John Sloan (1871–1951). *Connoisseurs of Prints*, from the series *New York City Life*, 1905. Etching, 4¹⁵/₁₆ x 7 in., see p. 59; 33. John Sloan (1871–1951). *The Picture Buyer*, 1911. Etching, 5¹/₄ x 7 in., see p. 61; 34. Edward Gregory Smith (1880–1961). *By the Edge of the Lieutenant River, Old Lyme, CT*, 1915. Oil on canvas, 30 x 38 in., see p. 63; 35. Michael Theise (b. 1959). *Dr. McLaughlin's Rack Picture*, 2000. Oil on board, 19 x 21 in.; 36. Peter Waite (b. 1950). *Hill-Stead*, 2010. Acrylic on aluminum panel, 26 x 20 in., see p. 65; 37. John Ferguson Weir (1841–1926). *East Rock, New Haven*. Oil on canvas, 25 x 30 in., see p. 67; 38. James Abbott McNeill Whistler (1834–1903). *Billingsgate*, 1859. Etching, 5⁷/₈ x 8⁷/₈ in., see p. 69; 39. James Abbott McNeill Whistler (1834–1903). *La Robe Rouge*, 1894. Lithograph, 7³/₈ x 6¹/₁₆ in., see p. 71; 40. Thomas Worthington Whittredge (1820–1910). *Catskill Mountains Twilight*, ca. 1863–65. Oil on board, 4³/₄ x 7⁷/₁₆ in., see p. 73; 41. Guy C. Wiggins (1883–1962). *Times Square*, 1931. Oil on board, 10 x 8 in., see p. 75; 42. Tom Yost (b. 1957). *Sunset from Painter Ridge Road I*, 2004. Oil on canvas, 9¹/₂ x 19¹/₂ in.

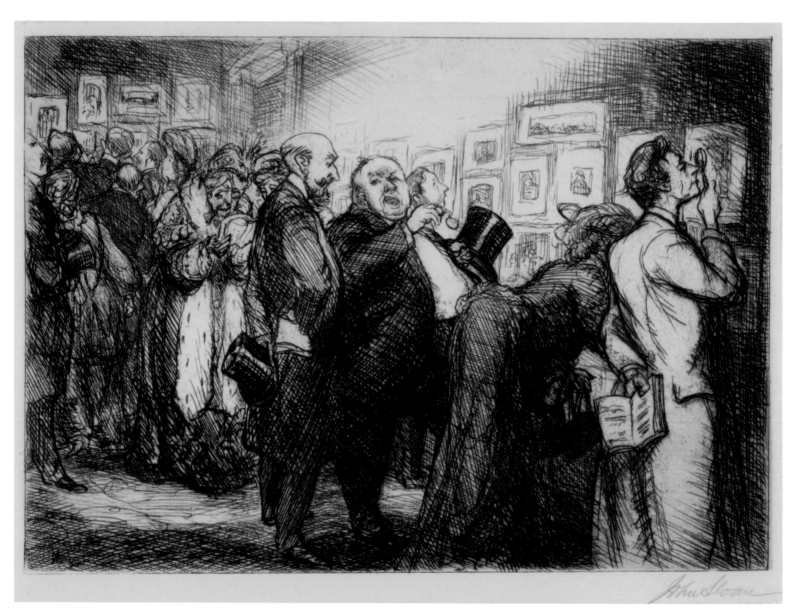

John Sloan (1871–1951). *Connoisseurs of Prints*, from the series *New York City Life*, 1905. Etching, 4 15/16 x 7 in.